GEORGIA O'KEEFFE

GEORGIA O'KEEFFE

the poetry of things

Elizabeth Hutton Turner

with an essay by Marjorie P. Balge-Crozier

THE PHILLIPS COLLECTION · WASHINGTON, D.C.

AND YALE UNIVERSITY PRESS · NEW HAVEN · LONDON

IN ASSOCIATION WITH THE DALLAS MUSEUM OF ART

Support for this exhibition has been provided by the National Endowment for the Arts, a federal agency

Published on the occasion of the exhibition *Georgia O'Keeffe: The Poetry of Things*

April 17–July 18, 1999
The Phillips Collection
Washington, D.C.

November 7, 1999–January 30, 2000
Dallas Museum of Art
Dallas, Texas

August 7–October 17, 1999
The Georgia O'Keeffe Museum
Santa Fe, New Mexico

February 19–May 14, 2000
Fine Arts Museums of San Francisco at the California
Palace of the Legion of Honor
San Francisco, California

Set in Monotype Bembo type by Highwood Typographic Services, North Haven, Connecticut
Printed by CS Graphics, Singapore

Library of Congress Cataloging-in-Publication Data
Turner, Elizabeth Hutton, 1952–
Georgia O'Keeffe : the poetry of things / Elizabeth Hutton Turner ; with an essay by Marjorie P.
Balge-Crozier.
 p. cm.
Includes bibliographical references and index.
ISBN 0-300-07935-4 (cloth : alk. paper). — ISBN 0-943044-24-3 (pbk. : alk. paper)
1. O'Keeffe, Georgia, 1887–1986—Exhibitions. 2. Still-life painting, American—Exhibitions.
I. Balge-Crozier, Marjorie P. II. Title.
ND237.O5A4 1999 98-32429
759.13—dc21 CIP

A catalogue record for this book is available from the British Library.

The paper in this book meets the guidelines for permanence and durability of the Committee
on Production Guidelines for Book Longevity of the Council on Library Resources.
10 9 8 7 6 5 4 3 2 1

Georgia O'Keeffe: The Poetry of Things was co-organized by The Phillips Collection,
Washington, D.C., and the Dallas Museum of Art

contents

PLATES FOLLOW PAGES 23, 75, AND I23

I have picked flowers where I found them —
Have picked up sea shells and rocks and pieces of
wood where there were sea shells and rocks and pieces of
wood that I liked
When I found the beautiful white bones
on the desert I picked them up and took them home too
I have used these things to say what is to me the
wideness and wonder of the world as I live in it

GEORGIA O'KEEFFE, 1944

foreword

the legacy of georgia o'keeffe is connected in many ways to objects that she collected and represented in her paintings. They alone most closely convey her chosen form of expression.

O'Keeffe's objects never substituted for the work of art. She never made assemblages like her friend and contemporary Arthur Dove. Color was her formal language. When asked whether the flower or the color was her focus, O'Keeffe refused to say. Instead she spoke of the primacy of aesthetics. "What is my experience of the flower if not color?" she declared. Though she explained little about her themes and sources, O'Keeffe credited her teacher Arthur Wesley Dow for giving her something to do with her finely honed skills in watercolor and oil. She also expressed an affinity for music and the economy of Chinese poetry. Toward the end of her life she often asked to be read to from two books: Wassily Kandinsky's *Concerning the Spiritual in Art* and Kakuzo Okakura's *The Book of Tea*. She particularly reveled in metaphor. Referring to a passage in *The Book of Tea,* she implored her nurse to "turn to the pages about flowers. . . . You know, he says that a butterfly is a flower with wings."

O'Keeffe once said toward the end of her long life, "I'm bored with my history, my myth." To which may be added more than a decade after her death and after numerous biographies the rejoinder, "So are we." Today the public may know more about elements of O'Keeffe's personal biography and the triumphs and tragedies of her life with the irascible Freudian-minded Alfred Stieglitz than they know of her deeply personal approach to art. Ironically, we still don't know enough about the philosophy and aesthetics underlying the choices she made in her work. O'Keeffe is popular and accessible but equally, if subtly, sophisticated. Museums haven't asked the right questions nearly enough. What can we say about O'Keeffe's creative process and sources?

To see and appreciate O'Keeffe's method is to become deeply rooted in the American experience—particularly America's close identification with nature. Understanding O'Keeffe's process can be as simple as taking a walk outdoors or as complex as transcending visible reality, capturing what she called "the unexplainable thing in nature." One avenue—what an artist sees and selects—takes us into

Museum of Fine Arts, St. Petersburg, Florida
National Gallery of Art, Washington, D.C.
Norton Museum of Art, West Palm Beach, Florida
Gerald and Kathleen Peters, Santa Fe, New Mexico
Philadelphia Museum of Art
The Phillips Collection, Washington, D.C.
Dr. and Mrs. Meyer P. Potamkin
Hughes and Sheila Potiker
The Saint Louis Art Museum
San Diego Museum of Art
Paul and Tina Schmid
The University of Arizona Museum of Art, Tucson
Wadsworth Atheneum, Hartford, Connecticut
Whitney Museum of American Art, New York
Yale University Art Gallery, New Haven, Connecticut
Four Anonymous Lenders

Nothing is less real than realism. Details are confusing.
It is only by selection, by elimination, by emphasis that
we get at the real meaning of things.

GEORGIA O'KEEFFE, 1922

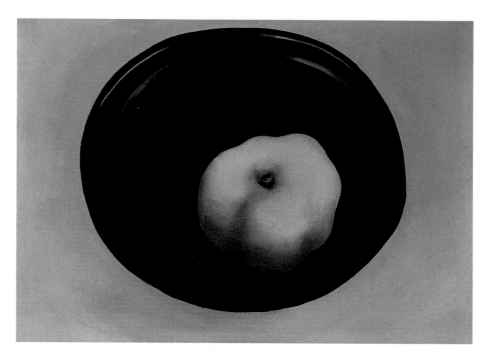

Figure 1. *Still Life with Apple,* 1921, oil on canvas, 10 x 14 in., Aaron I. Fleischman

the real meaning of things

ELIZABETH HUTTON TURNER

georgia o'keeffe is celebrated for her vivid depictions of flowers, leaves, bones, shells, and rocks. Yet, in spite of her identification with these objects, O'Keeffe's relationship to them remains hard to categorize. Typically, the artistic depiction of objects, the genre known as still life, is held to be a faithful representation of things in the real world. But O'Keeffe claimed few distinctions between abstraction and representation in her work. By her own account, her aesthetic was informed by her ability to select, not to describe: "Nothing is less real than realism," she explained. "It is only by selection, by elimination, by emphasis that we get at the real meaning of things."[1] This approach is abundantly evident in her depiction of a single apple, bone, or blossom (fig. 1). Is it still life? Perhaps.

At the core of O'Keeffe's art is a thing seen and objectified through formal analysis. Unlike other American modernists, however, Georgia O'Keeffe claimed little affinity with French painter Paul Cézanne, arguably the father of modern still life.[2] Instead, she acknowledged the importance of her teacher Arthur Wesley Dow. Dow's central precept of "filling space in a beautiful way" launched O'Keeffe on a new path, one that led to a unique confluence of Eastern and Western thought and a decidedly formalist approach. O'Keeffe recalled, "This man had one dominating idea; to fill a space in a beautiful way—and that interested me. After all, everyone has to do just this—make choices—in his daily life, when only buying a cup and saucer. By this time I had a technique for handling oil and water color easily; Dow gave me something to do with it."[3] The near mythical story of O'Keeffe's education and career as an artist and a teacher bears retelling to explain how her aesthetics and her lifelong affinity with objects involved the methods and philosophy of this eclectic educational reformer and his sources.[4]

At a glance, Arthur Wesley Dow (1857–1922) seems an unlikely addition to O'Keeffe's list of liberating influences (fig. 2). "Pa Dow," as she affectionately called him, was a landscape painter from Ipswich, Massachusetts, and on the face of it, not modern. His own style never moved far beyond the synthetism of the Pont-Aven School.[5] Yet as a teacher he was a radical reformer. In his influential book *Composition* (1899)—which went through seven editions—Dow rejected

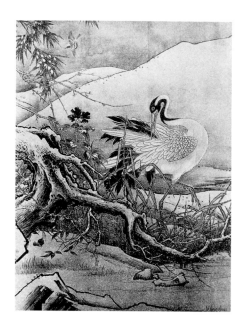

Figure 5. Sesshū, Detail of Stork and Plum Screen, Reproduced in Ernest F. Fenollosa, *Epochs of Chinese and Japanese Art*, vol. 2 (New York: Frederick A. Stokes, 1921), 85

ered Whistler a mere copyist when compared to the eighteenth-century artist Hokusai.)[18] He nonetheless encouraged his students to think of such modernists as comrades in arms whose common struggle against academic conventions were easily witnessed in New York.[19]

From Morningside Heights at 120th Street in New York City, O'Keeffe was only a trolley-car ride away from galleries showing strange shapes and colors manifesting psychic intent or pure emotion. Synchromists Stanton MacDonald Wright and Morgan Russell were at the Carroll Galleries in 1914, and Matisse could be seen at the Montross Galleries in 1915. Francis Picabia's collection of Picasso drawings and Marius de Zayas's assembly of eighteen African sculptures were displayed at Alfred Stieglitz's gallery 291 in 1914. What O'Keeffe learned about modern expression would have been tested at Columbia University. She recalled making much of synesthesia — the physical association of sound and color — walking the halls of the Teachers College, hearing the Victrola, and then suddenly sitting down to draw in a nearby classroom.[20] O'Keeffe also cultivated a certain independence as she worked separately on still lifes of her own choosing in Charles Martin's classes.[21] Membership in the National Woman's Party underscored her growing resolve for independent action. It was the desire to own fully her artistic expression that perhaps brought her closest to the emotional tenor of her generation. Just as Henri Gaudier-Brzeska declared in his journal from the trenches, "I shall present my emotions, by the arrangement of my surfaces," so O'Keeffe resolved after her first semester at Columbia, "I made up my mind to forget all that I had been taught and to paint exactly as I felt."[22]

By the fall of 1915, O'Keeffe, now teaching in Columbia, South Carolina, and nearly six months away from New York was on the eve of the creation of her first abstractions. Her letters to her friend Anita Pollitzer indicated that she was reading Wassily Kandinsky's *Concerning the Spiritual in Art* (1914) for the second time. Kandinsky's discussion of "inner necessity" in his treatise on abstraction must have read like a call to action to O'Keeffe: "The artist must be blind to the distinction between 'recognized' or 'unrecognized' conventions of form, deaf to the transitory teaching and demands of his particular age. He must watch only the trend of the inner need, and harken to its words alone."[23] His instruction echoed Dow's admonition that one ought "not to depend on externals, not to lean too much on anything or anybody."[24]

From October to December, O'Keeffe gauged and assessed her vision in her letters to Pollitzer. She spoke enthusiastically about "the woods turning bright."[25] Her keen appetite for color was sustained in Japanese fashion, as she posed within the periphery of her vision a single flower against the bureau or placed a vase of zinnias in her closet like a shrine to beauty. O'Keeffe next exchanged her brushes and advanced techniques for rudimentary charcoal. Like the ancient Buddhist priests Dow had described, she chose a monochrome medium as the vehicle for spiritual expression.[26] For inspiration she conducted a nightly vigil of stargazing, violin playing, and spontaneous drawing.

O'Keeffe claimed that her aesthetic awakening, an artistic rebirth of sorts, occurred in December while she was on her hands and knees filling papers on the floor with swaths of charcoal. Her marks indicate movements made with the whole arm, from the shoulder, holding the stick upright, touching down with keen control and concentration, as Dow recommended, "without resting the hand."[27] The configurations presented themselves variously as tendrils reaching up through the soil, an arching fountain, or waves sweeping across the shore. Perhaps they were none of these. The lines uncoiling across the empty paper and the luminous spaces left in their wake seem to have shaken the elements of style free from traditional restraints of composition.

O'Keeffe named the new charcoals *Specials,* possibly to signify their radical point of departure (fig. 6, pls. 2–5). And indeed they mark the start of something

Figure 6. *Special No. 2,* 1915, charcoal on laid paper, 23¾ x 18¼ in., National Gallery of Art, Washington, D.C.; The Alfred Stieglitz Collection, Gift of The Georgia O'Keeffe Foundation 1992.89.4

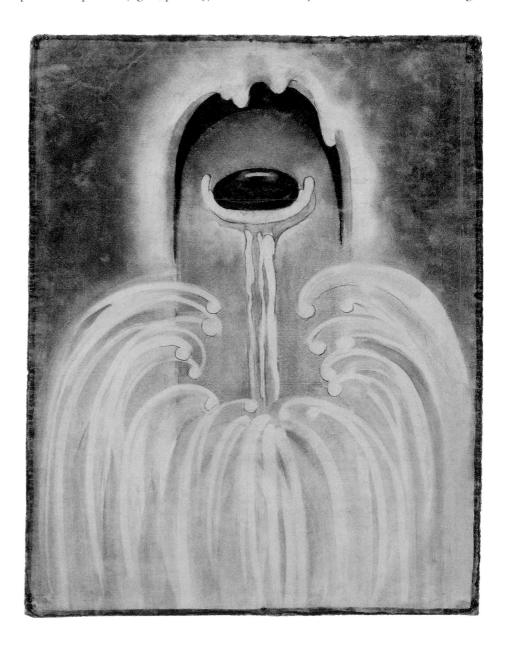

Figure 16. Alfred Stieglitz, *Georgia O'Keeffe,* 1919, gelatin silver print, 9¼ x 7⅝ in., The Metropolitan Museum of Art, Gift of Georgia O'Keeffe through the generosity of The Georgia O'Keeffe Foundation and Jennifer and Joseph Duke, 1997 (1997.61.17)

her finely machined control of color, and her simple geometries drawn from nature (the chevron, the spiral) aligned O'Keeffe with the new aesthetic concerns of an America inquiring after its own modernity. Had she adopted Stieglitz's cause?

Picture O'Keeffe, as Stieglitz did, united in purpose with an assembly of writers and artists such as Paul Rosenfeld and Charles Duncan around the summer supper table on the porch at Lake George (fig. 17). Outdoors, these modern-day Thoreaus invoked art and experience from "living poetry like the leaves of a tree, which precede flowers and fruit — not a fossil earth, but a living earth."[54] They conversed with particular facts of nature, but unlike their transcendentalist forebears, in part thanks to Dow's mentor Fenollosa, they were formalists.[55]

Cathay, Pound's adaptation of Fenollosa's compilation of Chinese poetry, had been circulating among them since April 1915.[56] Pound had peered into the calligrapher's strokes (mistakenly believing, like Fenollosa, that he was looking at pictographs) and had discovered his own exile's voice, a longing for a poetry of local realism in Cathay. The seasonal aspects of fern shoots unfold the lament of the Bowmen of Shu: "Here we are, picking the first fern-shoots and saying: When shall we get back to our country."[57] Pound would later credit Fenollosa's renewed emphasis on perception, together with a renewed consciousness of the structure of words — indeed, a renewed consciousness of the root and structure of all language — with enabling modern poets, like modern painters, to break free from romantic metaphor of mood or impression and to unfold a more objective system of expression.

The satisfaction of their formalism lay not in preserving vision but in devising with the means at their disposal a reduced, intensified, abstract equivalent for it. William Carlos Williams would articulate it best when he declared: "Compose. (No ideas but in things.)"[58] Stieglitz felt it most when he snapped the shutter of his handheld Graflex looking up at clouds. During the summer of 1921, surrounded by poets and a bumper crop in the old orchards, O'Keeffe first approached her idea of equivalence in the manner of an exquisite haiku when she painted a knobby green apple against a smooth black oval plate floating against an empty white field (pl. 14). If, as Fenollosa admonished, "nature has no grammar," then the simplicity of O'Keeffe's composition would supply it.[59]

Beyond their common inspiration in nature, these American writers and O'Keeffe shared a consciousness of the concrete rhythm and structure of their respective genres. Their expressions pertained to visible relations that they constructed with words and she in color. Yet when their words came in the form of criticism assigned to her paintings — expressions for which she herself claimed to have "no words" — O'Keeffe disavowed their association.[60] O'Keeffe had said that she painted with no thought of an exhibition, yet after Stieglitz filled the Anderson Galleries with a retrospective of her drawings and paintings in 1923, she was overwhelmed by the need to exhibit again to clarify the confusion (fig. 18). Critics assigned sexual metaphors — "painful ecstatic climaxes" — and ignored

the exquisite control underlying her designs.[61] Helen Appleton Read recalled O'Keeffe's complaining, "What if it is children and love in paint? There it is color, form, r[h]ythm. What does it matter if its origin is emotional or aesthetic?"[62]

The paintings for O'Keeffe's show of 1924 essentially forsook unnamed subjects and half-claimed analogies. Counteracting the vagaries of modern critics, O'Keeffe appears to have consulted the wisdom of the ancients for clarity. Teachings of the eleventh-century artist and theorist Kakki (Kuo Hsi) as recorded by Fenollosa recommended, "The comparing of a tree with man begins with its leaves."[63] Starting with the fundamentals in magnified patterns of leaves, she was, as she told Sherwood Anderson, "very much on the ground."[64] She added eight callas—about which she claimed no emotion—a vividly androgynous flower with a vaginal shape and a long protruding stamen that could confront and expose the Freudian prejudices of her audience. Annual exhibitions propelled O'Keeffe to invent and force her audiences to expect ever more dramatic performances of objects. "I made you take time to look," she later explained.[65] By way of exhibition, then, O'Keeffe would marshal her methods to clear away pictorial preconceptions; only now the lessons would be fiercely conveyed to a stormy mix of urbanites—critics, society matrons, artists, architects, philosophers, theorists, what Waldo Frank called "this Manhattan vortex."[66]

Picture O'Keeffe in the twenty-eighth-floor apartment in New York's Shelton Hotel as Frances O'Brien saw her in 1927: "Beside her a glass palette, very large, very clean, each separate color on its surface, remote from the next. As

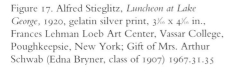

Figure 17. Alfred Stieglitz, *Luncheon at Lake George*, 1920, gelatin silver print, 3⁵⁄₁₆ x 4⁵⁄₁₆ in., Frances Lehman Loeb Art Center, Vassar College, Poughkeepsie, New York; Gift of Mrs. Arthur Schwab (Edna Bryner, class of 1907) 1967.31.35

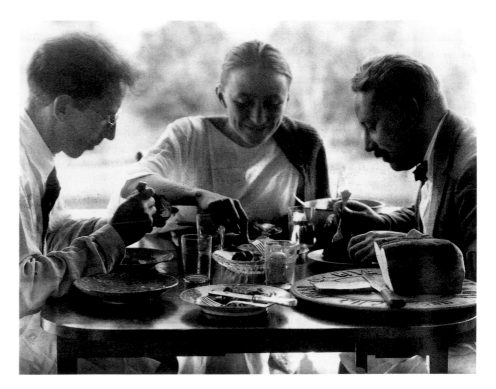

other painters in the exhibition — Marin, Hartley, Dove and Demuth — but it is impossible to compare her with them."[77] Two years later critic Murdock Pemberton similarly singled out O'Keeffe: "She, almost alone of contemporary painters, runs over the edge of her canvas; she is profligate where others save, generous to a bewildering degree."[78] Being "outside" was perhaps O'Keeffe's most avant-garde quality. Maintaining Dow's campaign to inculcate aesthetic values to a wide audience fostered a position outside. Pemberton clearly saw its usefulness for O'Keeffe: "Future historians can trace out the thin line of American endeavor, from the Revolution to 1912, and find scarce a trace of anything that will rise above the norm line of the chart. . . . And we bet that among those numbered as throwing bombs into the factory of standards and forms will be the little Texas school teacher."[79] Add to this persona O'Keeffe's growing finesse and her propensity for irony, and by the end of the 1920s you have images that defy boundaries and elude definition. In 1929, the year the callas unfurled fully a yard wide, the caricaturist Miguel Covarrubias dubbed her "Our Lady of the Lily" in the *New Yorker* (fig. 20, pl. 35). The black-and-white image portrayed O'Keeffe sleek and severe holding the calla like an icon with an identifying attribute. The painter and the flower had become one in the public mind. O'Keeffe vested the flower with the modern. She enlarged it by virtue of her experience of color. By her power to select and transform she freely reveled in its sexual metaphor or mitigated its effect if she so desired.[80] After seeing O'Keeffe's callas (and perhaps alluding to Fenollosa's idea of East and West synthesis), Willard Huntington Wright declared, "Nature and knowledge become one."[81]

In 1930 her last major flower series was completed with tongue in cheek. O'Keeffe's jack-in-the-pulpit, with its erect, bulbous, carnival shape, struts like the rooster of all flowers (fig. 22). She said she found it difficult to simplify.[82] When she divided the composition down the middle, the jack's gaudy stripes unfurled like a flag. She found no way to quiet it except to suppress nearly all the action. *Jack-in-the-Pulpit No. IV* (fig. 21) is muddy brown, nearly black, almost without air or breath, its rhythm held back. Stripped down, its composition relies solely on the glowing white contour of the single black stamen to shape the space.

Looking around at that moment, O'Keeffe, unlike Stieglitz, had found little to crow about. Certainly her aesthetics had not been affirmed in the attention and money secured by her exhibitions and such record prices as the purported twenty-five-thousand-dollar callas. Looking back longingly to Texas, she thought of a different forum. She told one interviewer in 1928, "I like teaching. I have missed it terribly. I like contact with those students who earned the money they spent."[83] In February 1929 Stieglitz told Hartley and Dove there would be no exhibition that year; "not for a long, — long, — long time," O'Keeffe told the critic Henry McBride.[84] Though in fact her yearly exhibitions would continue, O'Keeffe made it clear in other ways that she wanted to break free of old patterns

Georgia O'Keeffe

Figure 20. Miguel Covarrubias, *Our Lady of the Lily: Georgia O'Keeffe,* 1929, Courtesy The New Yorker Magazine, Inc.

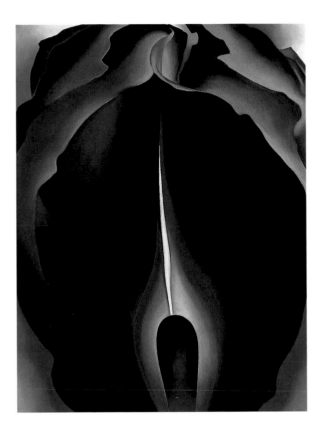

Figure 21. *Jack-in-the-Pulpit No. IV,* 1930, oil on canvas, 40 x 30 in., National Gallery of Art, Washington, D.C.; The Alfred Stieglitz Collection, Bequest of Georgia O'Keeffe 1987.58.3

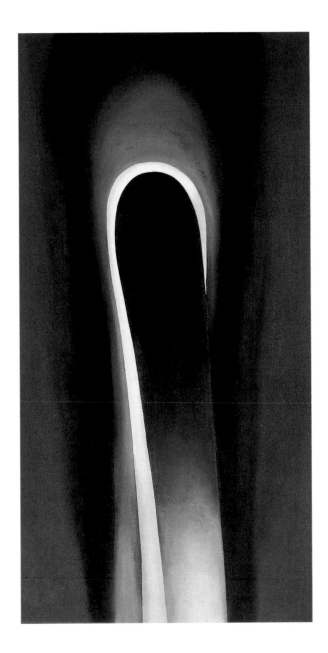

Figure 22. *Jack-in-the-Pulpit No. VI,* 1930, oil on canvas, 36 x 18 in., National Gallery of Art, Washington, D.C.; The Alfred Stieglitz Collection, Bequest of Georgia O'Keeffe 1987.58.5

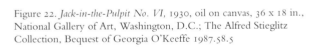

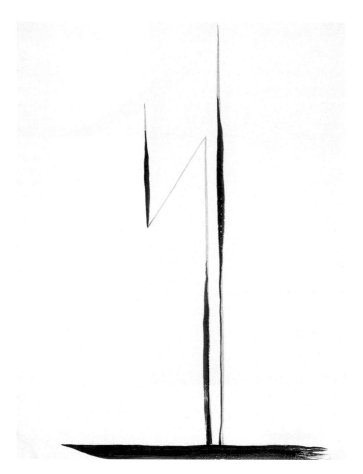

Plate 1. *Black Lines,* 1916, watercolor on paper,
24⅛ x 18⅞ in., The Georgia O'Keeffe Museum, Santa Fe,
New Mexico; Extended Loan, The Burnett Foundation

Plate 2. *Special No. 4,* 1915, charcoal on laid paper,
24⅛ x 18⅞ in., National Gallery of Art,
Washington, D.C.; The Alfred Stieglitz Collection,
Gift of The Georgia O'Keeffe Foundation
1992.89.6

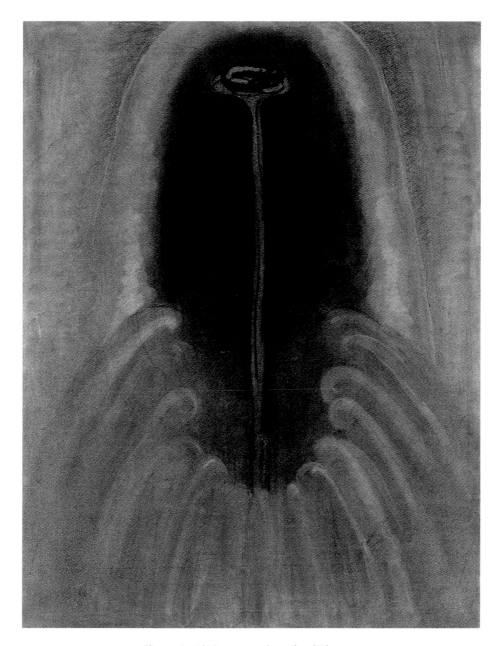

Plate 3. *Special No. 1,* 1915, charcoal on laid paper,
25 x 19 in., National Gallery of Art, Washington, D.C.;
The Alfred Stieglitz Collection, Gift of The Georgia
O'Keeffe Foundation 1992.89.3

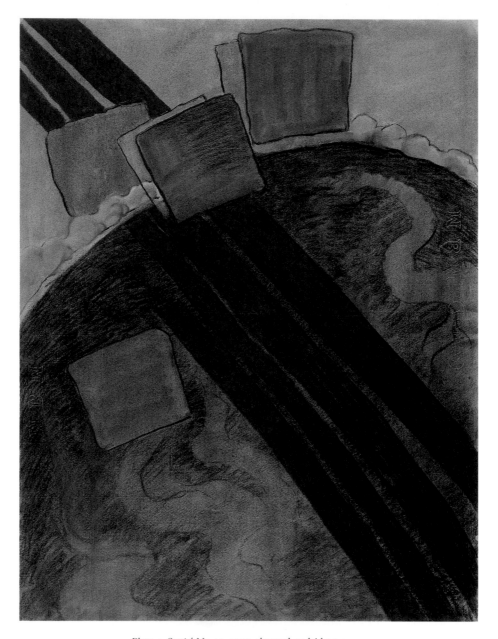

Plate 4. *Special No. 14,* 1915, charcoal on laid paper,
24⅝ x 18½ in., National Gallery of Art, Washington, D.C.;
The Alfred Stieglitz Collection, Gift of The Georgia
O'Keeffe Foundation 1992.89.9

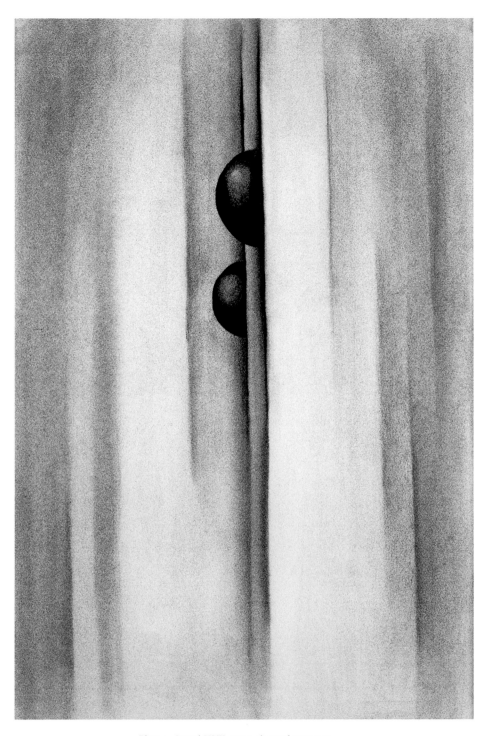

Plate 5. *Special XVII,* 1919, charcoal on paper,
22½ x 25½ in., The Georgia O'Keeffe Museum,
Santa Fe, New Mexico; Gift of The Burnett
Foundation and The Georgia O'Keeffe
Foundation

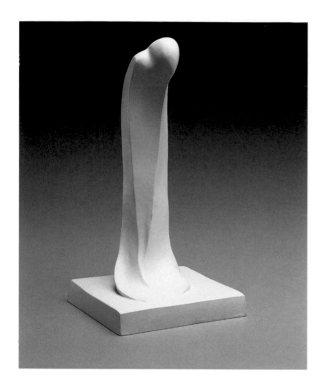

Plate 6. *Abstraction (Standing Figure)*, c. 1916, 1979–80, bronze, white lacquer, 10½ x 5 in., Collection of The Georgia O'Keeffe Foundation

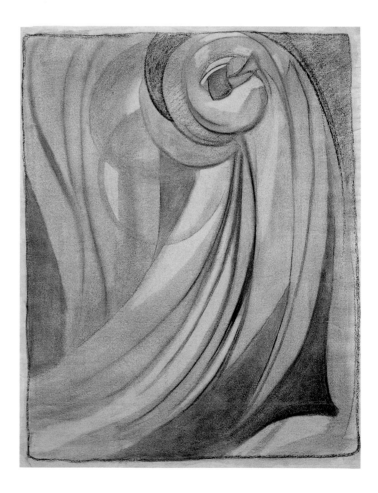

Plate 7. *Early No. 2,* 1915, charcoal on paper, 24 x 18⅞ in., The Menil Collection, Houston, Gift of The Georgia O'Keeffe Foundation

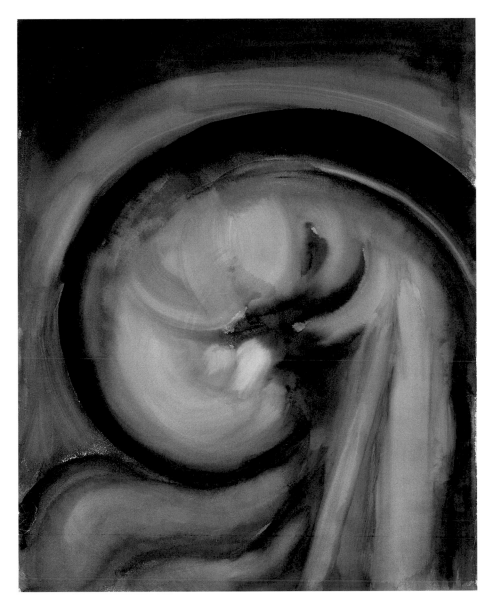

Plate 8. *Blue II,* c. 1917, watercolor on paper,
28⅞ x 22¼ in., The Georgia O'Keeffe Museum, Santa Fe,
New Mexico; Gift of The Burnett Foundation

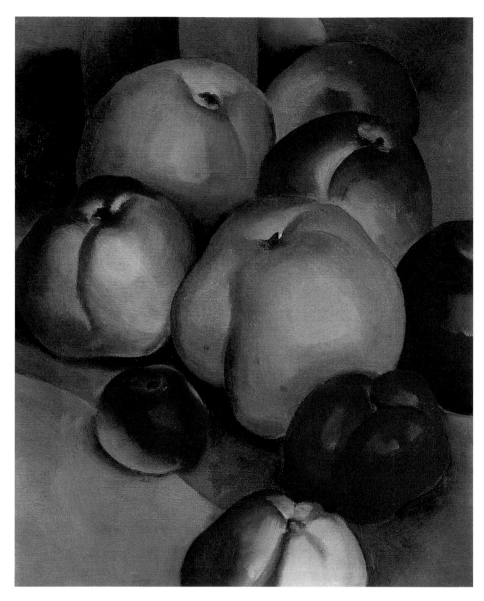

Plate 12. *Apple Family A,* 1921, oil on canvas,
9⅞ x 7⅞ in., Collection of Gerald and Kathleen
Peters, Santa Fe, New Mexico

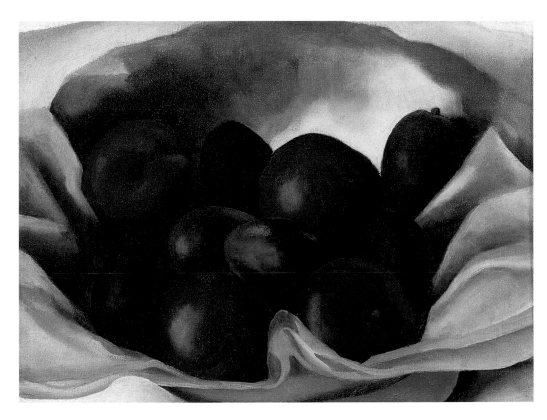

Plate 13. *Plums,* 1920, oil on canvas, 9 x 12 in.,
Collection of Paul and Tina Schmid

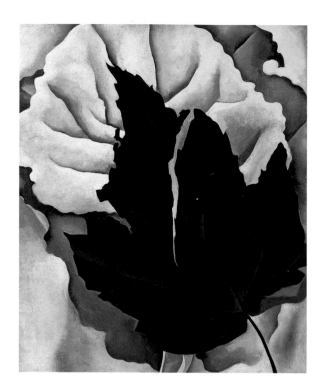

Plate 16. *Pattern of Leaves,* c. 1923, oil on canvas,
22⅛ x 18⅛ in., The Phillips Collection, Washington, D.C.

Plate 17. *Large Dark Red Leaves on White,* 1925,
oil on canvas, 32 x 21 in., The Phillips Collection,
Washington, D.C.

Plate 18. *Autumn Trees, The Maple,* 1924, oil on canvas, 37½ x 31 in.,
The Georgia O'Keeffe Museum, Santa Fe, New Mexico; Gift of The
Burnett Foundation and Gerald and Kathleen Peters

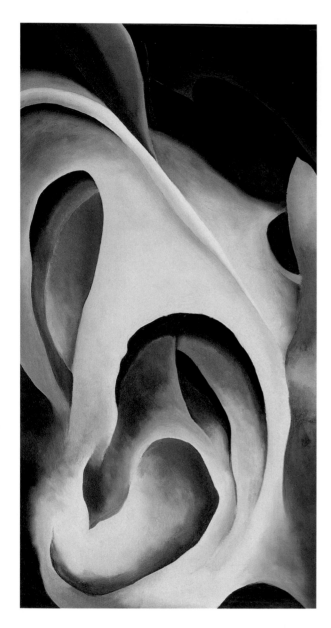

Plate 19. *Leaf Motif #2,* 1924, oil on canvas,
35 x 18 in., McNay Art Museum, Mary and Sylvan Lang Collection

*[It is] the unexplainable thing in nature that makes me
feel the world is big far beyond my understanding — to
understand maybe by trying to put it into form. To find
the feeling of infinity on the horizon line or just over
the next hill.*

GEORGIA O'KEEFFE, 1976

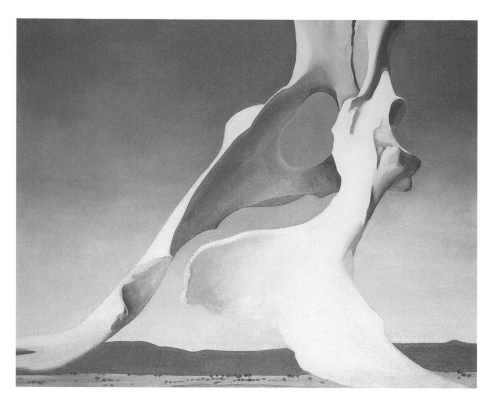

Figure 27. *Pelvis with the Distance,* 1943, oil on canvas, 23⅞ x 29¾ in., Indianapolis Museum of Art, Gift of Anne Marmon Greenleaf in memory of Caroline Marmon Fesler

still life redefined

MARJORIE P. BALGE-CROZIER

georgia o'keeffe's aesthetic path to her depiction of that last door in her Abiquiu house began auspiciously in the spring of 1908, when she won first prize for painting in William Merritt Chase's still-life class at the Art Students League in New York City. The artistic promise suggested in the skillfully rendered depiction of a dead rabbit and copper pot would be fulfilled in later life, but not before she had rejected most of what Chase's style stood for in an effort to find expression for her own feelings about "things." Her stylistic development would include Eastern influences and ways of thinking about objects that enabled her to help redefine the tradition of still-life painting in Western art and give viewers a new way of looking at the world—one that bridged East and West—in much the same way that her nineteenth-century predecessor James A. M. Whistler had done for portrait and landscape painting.

Still-life painting in Western art is basically about the observation of things— dishes, food, flowers—that have a long history of use in Western culture dating back to antiquity. As Norman Bryson pointed out in his critical study of still-life painting, these things "can be taken entirely for granted, from one generation to the next. They require no attention or invention, but emerge fully formed from the hand of cultural memory; and it is because they store such enormous forces of repetition that they are universally overlooked."[1] Over the centuries Western artists devised many ways to draw attention to these overlooked things.

The training Georgia O'Keeffe received under Chase, a master of still-life painting (fig. 28), grounded her in the fundamentals of the genre while encouraging her to observe objects closely and experiment with new ways of representing them. Yet Chase's brand of realism could not convey O'Keeffe's more subjective, emotional responses to the things around her. It was under the influence of Arthur Wesley Dow's Asian-inspired theory of composition, which emphasized design rather than representation, that she found the freedom to begin concentrating on colors and shapes corresponding to her feelings. Dow did not entirely throw over the Western tradition of representation with its illusionary perspective and chiaroscuro, but he did hold that it was wrong to start with it. As he put it in

Composition, his instructional text for the use of students and teachers, "One uses the facts of nature to express an idea or emotion. . . . Mere accuracy has no art-value whatever."[2]

Dow's tripartite theory of line, *notan* ("dark, light"), and color synthesized Eastern and Western ideas for composing a picture, while his notion that one created art to express an idea or emotion reflected symbolist aesthetics prevalent in much of late nineteenth-century art and literature.[3] This subjectivist movement, led by the poets Jean Moreas and Stéphane Mallarmé, rejected realist conceptions of art as tied to the exterior world in favor of subject matter derived from an interior world of ideas, feelings, and emotions. For a symbolist painter such as Paul Gauguin, colors and forms could evoke these feelings and serve as an equivalent for the subject depicted.[4]

If O'Keeffe first encountered these ideas under Dow, she had them reinforced through her own readings in modern art theory (much of it found in Alfred Stieglitz's *Camera Work*) and ultimately through contact with Stieglitz himself and his circle of artists and critics in New York.[5] The 1915 series of charcoal abstractions that brought her to Stieglitz's attention embodied emotions that resonated with his belief that art had to be an honest expression of the creator's feelings. When her initial experiments in this vein proved too open to sexual interpretation, O'Keeffe returned to still life in the 1920s, but she radically altered the scale and presentation of her subjects in ways that make us equally aware of the art and the artist as well as the thing re-presented—a truly modern contribution to a venerable Western tradition.

Figure 28. William Merritt Chase's class at The Art Students League of New York, c. 1907, Photograph archives of The Art Students League of New York

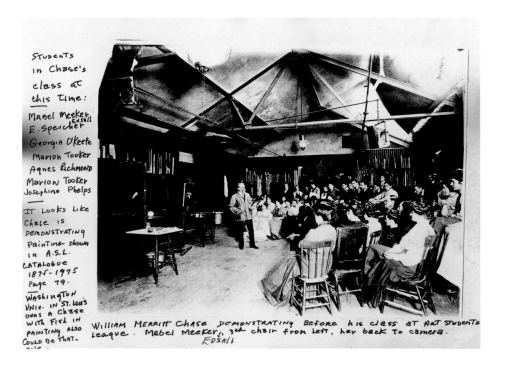

By comparing her work with that of her predecessors, we can clarify how far she transcended their approach to the genre as she adopted a modern, self-reflexive mode that often removed the objects from the culture in which they were embedded and repositioned them in her world as her things. It may be said that she took still life, called *nature morte* ("dead nature") by the French, and made it *nature vivante*—nature revivified for an audience that had stopped looking.[6]

The story of O'Keeffe's contribution to American art history has been told many times during her long life and in the years since her death in 1986. A good deal of that story has been shaped by the mythmaking of her mentor, dealer, and husband, Alfred Stieglitz; other parts reflect the vagaries and fluctuations of criticism. Seldom is the work itself allowed to suggest the path of aesthetic awareness and understanding, yet that is the approach artists prefer and one O'Keeffe undoubtedly would have approved, as she was often amazed by what was written about her. It is appropriate, then, to begin by looking at O'Keeffe's work and her way of seeing.

A PRIZEWINNING PAINTING

The things that O'Keeffe saw and learned to paint in her early training were probably not objects that she chose. They would have been selected and arranged by the instructor for the primary purpose of teaching a student to look closely at objects, to observe shapes, textures, colors, light, space, and relations and then to translate those observations onto the two-dimensional surface of paper, canvas, or board. Faced with dusty bottles, toys, blocks, and assorted bits of unidentifiable junk heaped at random on a stand in the middle of the room, the student learns to look at objects in wholly new ways. The ability to perceive, to truly see, gradually replaces the learned conceptual way of thinking about things. Objects acquire greater emotional resonance as the student draws his or her own possessions and begins to recognize the importance of still life in the practice of art.

If anyone could enthusiastically convey the importance of this genre, it was William Merritt Chase, O'Keeffe's instructor from 1907 to 1908. Chase had begun his career creating meticulously rendered still-life paintings of flowers and fruit, and although he had gained a reputation as a painter of portraits, interiors, and landscapes, after the turn of the century he was again doing still lifes. Paraphrasing Gustave Courbet, he told his students, "If you can paint a pot you can paint an angel."[7] Chase's rapidly brushed canvases of pots, fish, fruits, and vegetables were inspired by the earlier eighteenth-century masterpieces of Jean-Baptiste-Siméon Chardin and the nineteenth-century works of Antoine Vollon, a French painter involved in the revival of Chardin's style.[8] He passed on his knowledge and love of this still-life tradition to his students, as O'Keeffe herself recalled:

The Chase Still Life Class was much more fun. Every day we all had to paint a new still life. Then once a week William Merritt Chase came in to criticize. . . . There was some-

visible close at hand. These aspects of Chardin's style indicate a concern for the act of painting. Still life no longer functions as hidden symbolism or a celebration of wealth. Instead, it is a vehicle to investigate observation and representation. No wonder that Chardin is influential in the development of modern art.[12]

The simplicity of Chardin is only relative. His rabbit, pot, quince, and chestnuts occupy a rational space congruent with the age of rationalist thought he lived in. The things in his painting refer to the world of the kitchen and meal preparation. This is also true of Chase's still lifes, although his dark tonalities and bravura brushwork owe much to the Munich tradition he encountered in his early studies abroad. O'Keeffe's rabbit and pot, by contrast, are not as clearly part of that kitchen theme. Knowing the tradition, we tend to assume that they are, but the space is ambiguous. There is no hint of a table or wall. The rabbit is not tied as though it were game that had been hung, and the pot to cook it in has no handles or cover—it is merely a copper cylinder. The simplification underscores the fact that this is a painting first and foremost.

With only two recognizable objects in this space, one is tempted to think about what else may have been in the original arrangement that O'Keeffe decided to leave out. A glance at Chase's *An English Cod,* 1904 (fig. 31), which operates on a similar diagonal composition, makes a good comparison. Chase uses a scaled gradient from the pot in the back through the cod in the center to the small fish in the lower right corner whose colored iridescence balances the darker, large kettle in the rear. O'Keeffe's composition also achieves balance, but more daringly. Her pot and rabbit are pushed into the upper right corner and supported by the empty space of the other half of the canvas—a space that is an equally important part of the design and weighs in as a third motif.

The presence of this empty foreground, the asymmetrical composition, and the close, tonal harmonies may have been inspired by another of Chase's paintings, an earlier interior scene, *Hide and Seek,* 1888 (fig. 32). These stylistic elements owe much to Whistler's "arrangements" and the late nineteenth-century interest in Japanese art that prompted such artists as Whistler and Chase to collect Japanese prints, fabrics, and ceramics. In *Hide and Seek,* Chase played off the large, empty space of the room in the foreground against the background rectangles of wall, chair, picture, and curtain, all of this enlivened by the irregular shapes of the two little girls placed on a visual diagonal from lower left to upper right. The real subject of the painting is space, something that O'Keeffe is obviously beginning to experiment with in her work, too. Chase's japonisme would prepare her for Dow's Asian-influenced principles of composition, which relied on a preference for asymmetry and blank space, but it would be several years before she encountered his idea that art was about "filling a space in a beautiful way."

Meanwhile, O'Keeffe's rabbit and pot, though denied a secure ground plane, are anchored in the space of the painting by the more traditional Renaissance device of chiaroscuro. Light and shadow suggest that the objects have weight and

Figure 31. William Merritt Chase, *An English Cod,* 1904, oil on canvas, 36¼ x 40¼ in., In the Collection of The Corcoran Gallery of Art, Washington, D.C.; Museum Purchase, Gallery Fund 05.5

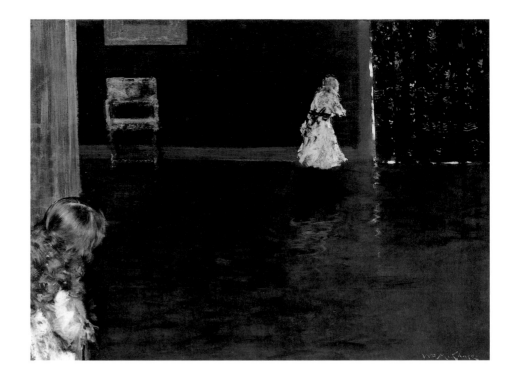

Figure 32. William Merritt Chase, *Hide and Seek*, 1888, oil on canvas, 27⅝ x 35⅞ in., The Phillips Collection, Washington, D.C

mass. They are part of a Western European way of looking at and representing things on a flat surface, pictorial conventions O'Keeffe is well on her way to mastering and manipulating. For these skills Chase awards her first prize—high honor indeed, but ultimately not a direction that O'Keeffe chooses to pursue. When she returns to depicting animals later in her career, they will be stripped of skin and flesh. Only the underlying skeletal structure will be important, and it will be used to signify a new way of looking at the world.

"TO SEE TAKES TIME"

A flower is relatively small. Everyone has many associations with a flower — the idea of flowers. You put out your hand to touch the flower — lean forward to smell it — maybe touch it with your lips almost without thinking — or give it to someone to please them. Still — in a way — nobody sees a flower — really it is so small — we haven't time — and to see takes time, like to have a friend takes time. If I could paint the flower exactly as I see it no one would see what I see because I would paint it small like the flower is small.

So I said to myself — I'll paint what I see — what the flower is to me but I'll paint it big and they will be surprised into taking time to look at it — I will make even busy New Yorkers take time to see what I see of flowers.[13]

O'Keeffe's well-known explanation of why she decided to paint her enlarged views of flowers is clearly a statement about the importance of observation, especially in a busy, urban setting. Writing fifteen years after she had done the first large-scale flower paintings in 1924, the artist goes on to recall that she had indeed made people look, but when they did, they hung all of their associations

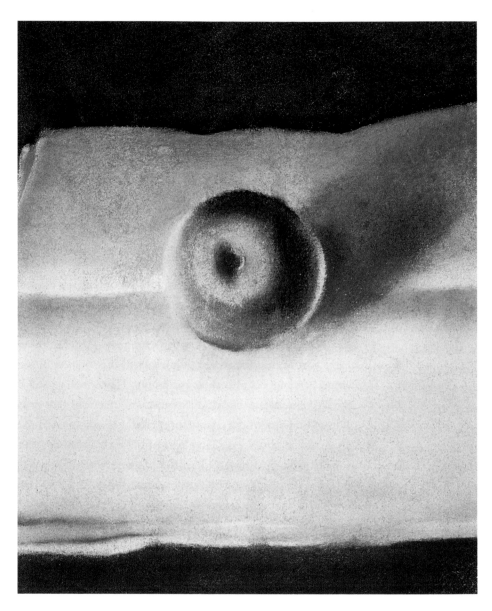

Figure 34. *Apple,* c. 1921, pastel on paper, 8¾ x 7¼ in., Private collection, Courtesy Greenberg Van Doren Gallery, St. Louis, Missouri

Disciplined and independent, she could control this genre to a much greater degree than she could the figure or landscape. She could study the objects with an intensity that made their shapes conducive to abstraction and mystery when represented in paint. As she said, she rarely painted anything she didn't know well, and that meant she needed time to look closely at a thing from many angles to decide what she wanted to do inside her head before starting to work.

So it is that O'Keeffe's still lifes from the early 1920s are a series of explorations in looking at things close at hand—the fruit and vegetables grown at Lake George, the leaves picked up and examined in all of their various shapes, the clam shells gathered in Maine, the flowers bought in New York. Yet if we compare them to the real things or to other artists' representations of such things, it rapidly becomes evident that O'Keeffe has made these objects uniquely hers. She has recognized, as have most modern artists, that the work of art is an object itself, a thing apart from that which is represented. All the illusionistic attention to detail that had characterized the still-life tradition since its inception in antiquity had no relevance in a world where the camera could do the same task better and the application of pieces of paper to the surface of the canvas—the collages of Pablo Picasso and Georges Braque—carried trompe l'oeil to a new level of reality.

When we confront one of these early works, such as *Green Apple on Black Plate*, 1922 (pl. 14), we are startled by the utter simplicity of the design, the reduction to shape and color as the only factors that can carry aesthetic meaning. We might go on to think about what apples have meant symbolically and historically, what they meant to Stieglitz and his group, and all of this is important if we know that O'Keeffe did many paintings of apples.[27] Yet looking only at that single work, as O'Keeffe did herself, the sociohistoric context seems insignificant; the sheer presence of the shapes and their colors exists outside of, or more accurately alongside of, their referents in the real world. It is worth noting that in most of her paintings of fruit and flowers O'Keeffe does not locate the object in the usual domestic space of a garden or kitchen. Even when use might be indicated, such as reaching to pick up an apple to eat, we are reluctant to do so because the fruit is so clearly an object or thing in a space that is "art." As we contemplate this new reality of the painting we can begin to understand what O'Keeffe meant when she said in 1922, "It is only by selection, by elimination, and by emphasis that we get at the real meaning of things."[28]

For O'Keeffe the meaning would reside primarily in shape and color and the emotional reaction they could evoke. One could look closely at nature and the object, but to reproduce every detail would only confuse the viewer, and such veristic realism could not hope to elicit the same awestruck reaction it got in the nineteenth century. God might still inhabit the details of modern architecture, as he did for Mies van der Rohe, but he had long since departed the scene for most painters, O'Keeffe included.

Leaves and Flowers

What O'Keeffe chooses to notice and paint is sometimes outside the usual range of subject matter in Western art. This is the case with the animal bones of the 1930s, but it is also true for the various leaf paintings executed mainly in the 1920s. Leaves by themselves do not turn up in the history of still-life painting until O'Keeffe elevates them to that privileged position. They were obviously a necessary part of botanical art, and they could be used to teach compositional principles as Dow advocated. O'Keeffe acknowledged that she did this when she taught, recalling that one of Dow's "exercises was to take a maple leaf and fit it into a seven-inch square in various ways. Of course, when I got to north Texas there was nothing like a leaf to use."[29]

Many of O'Keeffe's leaf paintings could indeed be seen as formal exercises to fit shapes into other shapes, play with light and dark patterns in unexpected combinations, or repeat interesting designs in ways that activate the space of the canvas.[30] *Pattern of Leaves,* c. 1923 (pl. 16), for example, has a distinct circular notch in the edge of the leaf in the upper right corner that is repeated in reverse and diminished scale on the upper left edge of the maple leaf in the foreground. These are not accidents of nature; they are considered acts of the artist. So, too, are the decisions to position leaves against leaves, as happens in *Brown and Tan Leaves,* 1928 (fig. 35, pl. 39), and *Dark and Lavender Leaf,* 1931 (fig. 36).

In all three works O'Keeffe places the subjects close to and parallel with the frontal plane of the picture, giving them an iconic status usually reserved for the figure or face in Western art. One is tempted to call them leaf portraits, yet there is not enough botanical specificity to justify that. One might also be tempted to call them portraits of O'Keeffe, because they seem important and we are reluctant to let them just be leaves. As Pierre Schneider observed in writing about Henri Matisse's art, "The more a form is simplified, the more it clamors to be connected with a complex intellectual horizon."[31] In our highly literate culture we search for a narrative meaning rather than permit the visual to remain visual, particularly when it is something we would not usually look at. Thus Roxana Robinson believes that many of O'Keeffe's still lifes are actually self-portraits or at least references to her state of mind, and that the leaf pictures of the twenties show a fragile presence, torn and broken, often overpowered by surrounding elements.[32]

The issue of self-portraiture is valid and will be examined with reference to other works. Certainly Stieglitz, inspired by New York Dada, encouraged the artists in his circle to create abstract self-portraits and O'Keeffe participated in these activities.[33] But Robinson's "reading" seems off the mark considering the overall strength of these frontal shapes and the possibility that the tears are merely a reference to the actual pattern of disintegration that occurs in a fallen leaf.

For a completely different response to this subject matter one can turn to O'Keeffe's contemporary, the critic Lewis Mumford, who owned such a painting. Writing to the artist in February 1929 he says, "When I reached the lowest depth

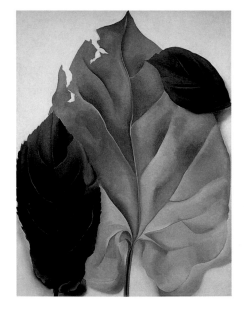

Figure 35. *Brown and Tan Leaves,* 1928, oil on canvas, 40 x 29⅞ in., Collection of Gerald and Kathleen Peters, Santa Fe, New Mexico

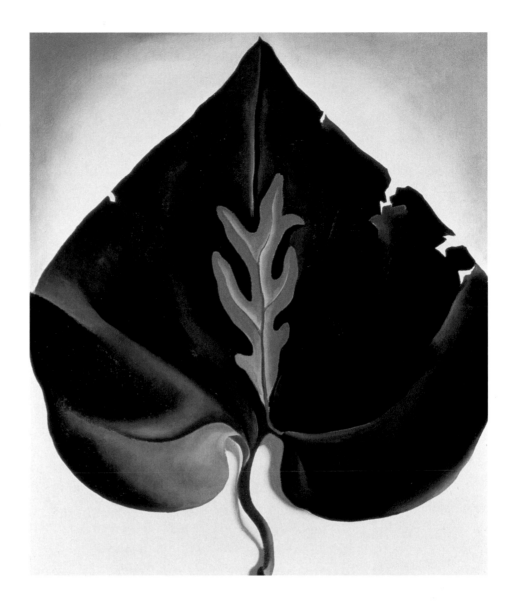

Figure 36. *Dark and Lavender Leaf*, 1931, oil on canvas, 20 x 17 in., Collection of the Museum of Fine Arts, Museum of New Mexico, Gift of the Estate of Georgia O'Keeffe

of winter depression last week, lying in bed with a sore throat, I asked Sophie to put your picture (that of the flaming and somber oak leaves) in front of me so I could see it: and I swear it aided in my recovery, giving me an assurance that life was somewhere, if not in me!"[34]

If somber oak leaves could revive the depressed and ill, how much more life-giving were the great paintings of flowers that grew larger in scale as the decade progressed, challenging the viewer to notice their bold colors and shapes. They leave no doubt that the artist loved her subject with an intensity unmatched by that of other flower painters. Indeed, O'Keeffe's passion for flowers was expressed early on in a letter of 1915 to Anita Pollitzer:

— *do you feel like flowers sometimes? Tonight I have an enormous bunch of dark red and*

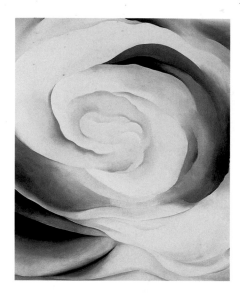

Figure 37. *Abstraction, White Rose II,* 1927, oil on canvas, 37½ x 31 in., The Georgia O'Keeffe Museum, Santa Fe, New Mexico; Gift of The Burnett Foundation and The Georgia O'Keeffe Foundation

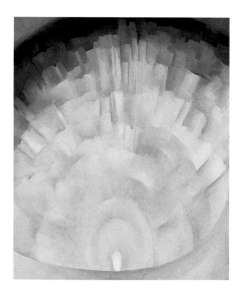

Figure 38. *Abstraction, White Rose III,* 1927, oil on canvas, 36 x 36 in., The Art Institute of Chicago, Alfred Stieglitz Collection, Bequest of Georgia O'Keeffe 1987.250.1

pink cosmos — mostly dark red — over against the wall — on the floor where I can only know they are there with my left eye — but with my right eye and part of my left eye — I can see a bunch of petunias — pink — lavender — and red lavender — one white — on my bureau — it is dark mission wood — They give me a curious feeling of satisfaction — I put them there so I could see them — just because I like them tonight — and put a wonderful bunch of zenias [sic] in the closet.[35]

O'Keeffe's romantic need to identify with a part of nature, as she expresses it in the opening line of the letter, recalls a similar comment by another member of the Stieglitz group, the poet William Carlos Williams. Of his poems Williams said, "When I spoke of flowers, I *was* a flower, with all the prerogatives of flowers, especially the right to come alive in the Spring."[36] One has the feeling that this same motivation drove O'Keeffe to enlarge the flowers she painted, and although the idea may owe something to photography, it is really a more primal urge to fuse with the subject that allows her to discard rational perspective and fill the visual field with organic colors and shapes. Crossing the boundary of scale and space that separates human beings from nature, she realizes with Williams that "there is no thing that with a twist of the imagination cannot be something else."[37]

Williams is speaking of the artist's power to transmute reality, and it is precisely that power of inner vision that O'Keeffe also uses to suggest relations between the micro and the macro in the natural world. Thus her two abstractions of the white rose done in 1927 resemble cosmic phenomena on the sublime scale. The swirling patterns of *Abstraction, White Rose II* (fig. 37, pl. 29) might be a cloud-filled sky or the view down into a snowstorm from the height of a New York skyscraper. In *Abstraction, White Rose III* (fig. 38, pl. 30), the small oval rising from the arc at the bottom is the interior of a flame rather than a stamen, and the concentric, radiating brushstrokes that build from it to fill the black void fluctuate and flicker like the aurora borealis in the dark, northern winter skies.[38] O'Keeffe may have seen this wondrous nighttime event during her youth in the Midwest, but the white arc could also refer to light coming on the plains or above *Red Hills, Lake George,* 1927 (The Phillips Collection)—a painting she does in the same year as the white rose abstractions.

If the rose abstractions lend themselves to interpretative speculation, that is not the case with *Iris [Dark Iris I]* (pl. 23), also from 1927. We have no trouble identifying the flower as one of O'Keeffe's favorite black irises obtained during the brief period they were in season each year from New York florists. This seems to be a fairly straightforward, realistic depiction with perhaps a background reference to the tissue paper the flower could have been wrapped in at purchase. There is a sensual quality to the rendering of light on the upper petals in keeping with the delicacy of such a bloom. Yet the size of the painting is daunting. Measuring thirty-two by twelve inches, this iris has a powerful presence that overrides any notions of fragility we might have associated with flowers.

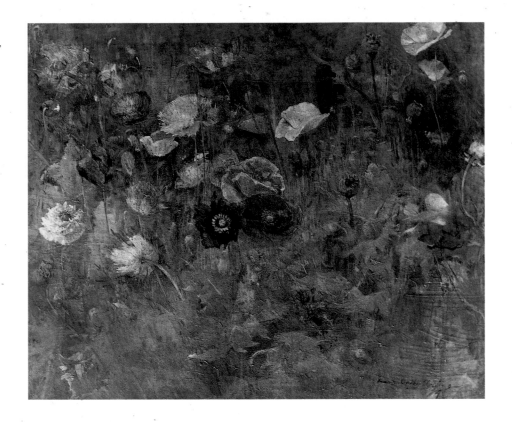

The paradox of linking strength and monumentality to something as inherently delicate and temporal as flowers is an idea that perhaps only O'Keeffe could have made visible. At least it is her contribution to redefining the genre of floral still-life painting. We can appreciate the significance of that contribution if we compare, for example, her rendition of a *Poppy* from 1927 (fig. 41, pl. 33) with Maria Oakey Dewing's *Bed of Poppies,* 1909 (fig. 39), and Charles Demuth's *Red Poppies* from 1929. O'Keeffe's work measures thirty by thirty-six inches and features a close-up view of a scarlet oriental poppy positioned so that we look down into the flower. The upper background fluctuates from white to a complementary green, but the space it represents cannot be identified as air or garden. It is the out-of-focus, compressed middle ground that O'Keeffe apparently borrowed from photography.[39] Although her use of crisp line and meticulously brushed surfaces convinced contemporary critics that hers was a photographically real style, there is in fact none of the surface detail that a camera can record. And O'Keeffe seldom uses light to distinguish illusionistic textures that might reinforce that type of realism. Shape, color, and pattern convince us this is a poppy, albeit one that will bloom forever.

This is not true for Dewing's bed of poppies, which are painted on a canvas twenty-five by thirty inches, nearly as large as O'Keeffe's. These flowers exist in air and sunlight, in the natural green of a garden. There is a variety in the blooms, buds, and seedpods that hints at botanical accuracy and observation, while nig-

Figure 40. Charles Demuth, *Red Poppies,* 1929, watercolor and pencil on paper, 13⅞ x 19¼ in., The Metropolitan Museum of Art, Gift of Henry and Louise Loeb, 1983 (1983.40)

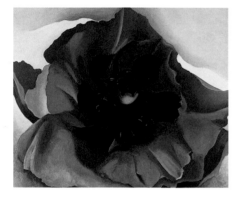

Figure 41. *Poppy,* 1927, oil on canvas, 30 x 36 in., Museum of Fine Arts, St. Petersburg, Florida; Gift of Charles and Margaret Stevenson Henderson in memory of Jeanne Crawford Henderson

gling detail is suppressed in the interest of a more impressionistic approach suggesting the momentary. Dewing moves close to her subject, but it is still more than an arm's length away, a comfortable distance for looking.

O'Keeffe would have agreed with Dewing's declaration that "the flower offers a removed beauty, more abstract than it can be in the human being, even more exquisite."[40] Dewing's reputation as a flower painter was well established in the late nineteenth and early twentieth century.[41] She was seen as a successor to John La Farge, with whom she had studied, and like O'Keeffe, she admired Asian art, particularly Japanese paintings. A screen by the early seventeenth-century artist Sotatsu in the Freer Collection was a favorite of Dewing's. The asymmetrical positioning of poppies in her own work owes something to her study of this Asian masterpiece, yet natural light and illusionistic depth are more important for her than flat pattern and design.[42]

Charles Demuth, a close friend of O'Keeffe's, shared her passion for flowers and gardening. Having inherited his mother's Victorian garden in Lancaster, Pennsylvania, he had a close-at-hand source for most of the flowers he painted. *Red Poppies* (fig. 40) is executed in watercolor and pencil on paper, his preferred medium and one that complements the precision and delicacy of his rendering. Although the background is white, there is a living quality to the plant that is very different from the iconic stasis of the O'Keeffe poppy. Demuth's flowers move in an unseen wind, unfurling petals that bear the creases from having been folded tightly in the bud and dropping spent petals in their transition to seedpod.

The passage of time—so important in nature and a frequent symbolic presence in still-life painting throughout history—is acknowledged by Demuth, as it was by Dewing. The temporal, however, is seldom a factor in O'Keeffe's view of things, which appears to focus more on the eternal or universal, the forms that repeat in the organic world. Even in the famous series of jack-in-the-pulpit paintings from 1930, where one might anticipate change through time, the effect is static—each view different, but frozen in place. The powerful movements implied by swirling lines and thrusting forms are always balanced in the space of the picture, controlled by the artist, who likewise controls the choice of colors.

O'Keeffe's colors can be as surprising as her use of scale. The intense reds that occur in the first two jack-in-the-pulpit paintings, for instance, might be explained as backlighting through the hood of the plant. But in the fifth version (pl. 43), the thin red line inside the green has no natural explanation—it is necessary for the "art" of the design, the complementary color of green that enlivens the work. So, too, the pinkish-purple used in *Red Canna,* c. 1924 (fig. 42), intensifies the reds and yellows one normally associates with the flower. Clearly O'Keeffe, following symbolist aesthetics, is willing to experiment with color to achieve an emotional impact equivalent to what she feels when examining the natural plant. Although there may well be symbolic or even theoretical reasons for certain of her color choices, the freedom to use color inventively is also tied

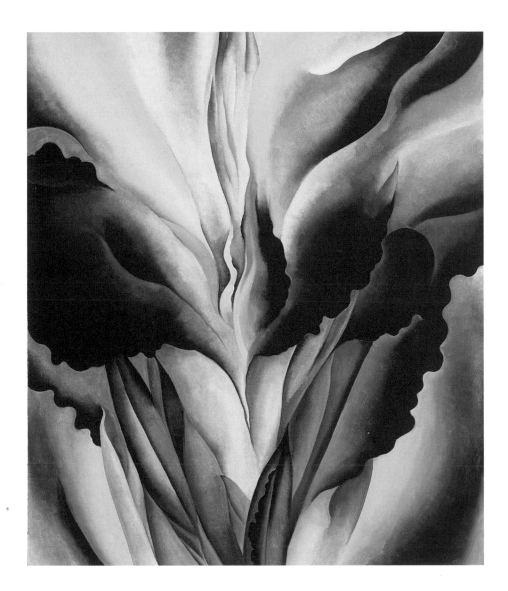

Figure 42. *Red Canna,* c. 1924, oil on canvas mounted on masonite, 36 x 29⅞ in., Collection of The University of Arizona Museum of Art, Tucson, Gift of Oliver James

to the discipline of exact observation.[43] Some of her colors can seem arbitrary, but there is frequently a basis in reality for making the decision and then manipulating it to achieve an effect.

And what an effect that color could have! Perhaps no one captured it better in words than did Demuth when he wrote to O'Keeffe after having seen her exhibition of 1926:

Your colour was the most exciting thing in this years art world. Why it has not been more mentioned shows, for me, how stupid the art (painting) writers are; there it is looking like no colour has looked before and nothing said.

When we have our houses you must do my music room, — just allow that red and yellow "cana" [sic] one to spread until it fills the room. That would be grand. Perhaps it would not even, then, be necessary to . . . have anyone play in this music-room.[44]

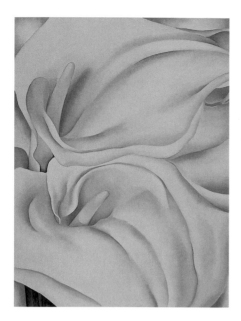

Figure 43. *Two Calla Lilies on Pink,* 1928, oil on canvas, 40 x 30 in., Philadelphia Museum of Art, Bequest of Georgia O'Keeffe for the Alfred Stieglitz Collection

Demuth goes on to describe another of O'Keeffe's canna paintings, a white one with pale blue "and a little cutting yellow-green which I found as [Marsden] Hartley would say,—'Just right, Charles.'"[45] That just-right quality is present as well in O'Keeffe's *Two Calla Lilies on Pink* of 1928 (fig. 43, pl. 35). Pink is the perfect color to set off the decorative, exotic shapes of the callas and exploit the possibilities of a sexual interpretation—something that O'Keeffe always tried to deny but one suspects deliberately provoked with this painting. The Freudian interpretations of her work continued throughout the 1920s, in spite of critics' recommendations that one should enjoy the paintings for themselves.[46]

This was not O'Keeffe's first painting of calla lilies. She started doing callas in 1923 as single flowers in a glass vase, perhaps following the lead of Demuth and Hartley, who had already found them aesthetically and symbolically interesting. Sarah Whitaker Peters makes a convincing argument that these paintings are the earliest of O'Keeffe's floral self-portraits. The inclusion of the vase, which has long served as a symbol of the female principle, strengthens this interpretation.[47] But what happens when the vase is not present and all one sees is the magnified view of the callas? Is this, too, a self-portrait? Yes, in the universal sense that every painting by an artist is a self-portrait; but that begs the question, and there is a more interesting way of understanding what O'Keeffe has done with these enlarged images.

Critics and historians looking at these paintings in the last decades of this century have many more options for explaining visual culture than did Stieglitz and his circle of intellectuals in the 1920s. We now equate modernity with the visual, and we recognize that "the relation between what we see and what we know is never settled," as John Berger noted.[48] Or as Norman Bryson puts it: "Viewing is an activity of transforming the material of the painting into meanings, and that transformation is perpetual. . . . [S]ince interpretation changes as the world changes, art history cannot lay claim to final or absolute knowledge of its object.[49]

This is not as limiting as it sounds. It does mean that we can suggest new ways of thinking about the O'Keeffe flowers based on what we understand of our visual culture. In traditional Western still-life paintings the objects are positioned at an "objective," reportorial distance where the facts of their representation allow the viewer to contemplate them passively. The space in the paintings is predicated on a Renaissance perspective system that favors the viewer yet gives the illusion of objectivity—literally meaning that there is enough distance between the viewer and the things looked at to imply emotional disengagement or an act of pure perception. The viewer can maintain a safe anonymity that permits, in effect, aesthetic voyeurism.

When O'Keeffe enlarges the magnitude and scale of her objects, she truly upsets the notion of aesthetic distance. Her radical, close-up views make vision synonymous with the self, thereby opening the way for more emotional interpretations and reactions on the part of the spectator, who can no longer comfortably

maintain the distance necessary for voyeurism. The viewer ends up feeling exposed in much the same way the artist has revealed herself, her vision, and her emotions. She has made us look—not at nature, but at what she has seen and made of it—a self-portrait that implicates the viewer.

This is a bold move, but not unexpected from a woman who could collaborate with Stieglitz in an extraordinary series of photographs of her body, many close-up and more revealing than the flowers. She is also a woman who could see and capture the beauty of the poisonous jimson weed, which she grew near her house in Abiquiu. The first one she had noticed was blooming at Puye Pueblo, and apparently her friend Rebecca Salsbury James gave her plants that she tended carefully, waiting for the spectacular flowers to emerge from the bud sheaths.[50] O'Keeffe painted the white trumpet flowers with their pale green or violet centers many times, and she is probably the only artist to do so other than Charles Willson Peale, who used the plant symbolically for its poisonous qualities. Peale's portrait of *John Beale Bordley*, 1770 (fig. 44), depicts the artist's friend and patron as a defender of American liberties opposed to the expansion of parliamentary power. As Edgar Richardson notes, this idea is "conveyed by the Latin words on the open book, 'We observe the laws of England to be changed,' and by the poisonous jimson weed growing at the base of the statue of English law."[51] Peale wrote to Edmund Jennings, who had commissioned the painting, that this native American weed "acts in the most violent manner and causes Death."[52]

When O'Keeffe discovered that jimson weed plants were poisonous, she tried digging them up but found that they were difficult to eradicate. The flowers, which open at dusk and close during the heat of the day, have an intoxicating scent—something that reminded her of "the coolness and sweetness of the evening."[53] The plant itself is coarse, with prickly seedpods—an unpromising candidate for the garden unless one is willing to wait for and look at the flowers. Like many native plants it was overlooked until the recent concern for natural gardening and xeriscaping brought it to the attention of growers. O'Keeffe celebrated the beauty of this weed decades before society caught up with her. Many of the flowers in her western paintings are in fact native plants—Indian paintbrush, evening primrose—that attracted her attention and sometimes also found a place in her garden. She was often amused that people who passed these same plants everyday along the road would ask her where she got them and what they were.

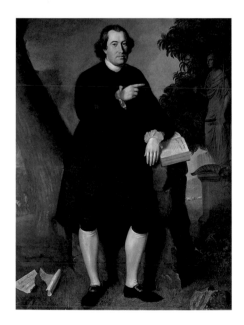

Figure 44. Charles Willson Peale, *John Beale Bordley*, 1770, oil on canvas, 79⅛ x 58³⁄₁₆ in., National Gallery of Art, Washington, D.C.; Gift of The Barra Foundation, Inc.

Bones

O'Keeffe's eye for the interesting and unusual served her well, particularly when she arrived in the Southwest, a land that appeared barren and harsh to many artists from the East who visited the area. Late in life O'Keeffe revealed that an interest in the things around her was an important facet of her character. In 1968 she wrote to Anita Pollitzer, disagreeing with Pollitzer's description of her as happy:

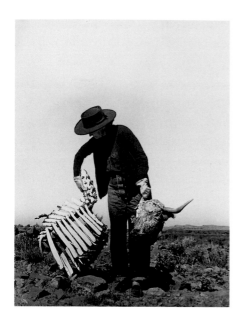

Figure 45. Ansel Adams, *Georgia O'Keeffe and Carcas, Ghost Ranch, New Mexico*, 1937, Ansel Adams Publishing Rights Trust

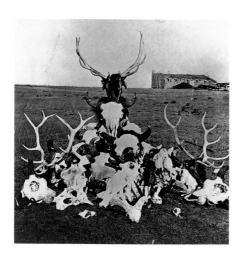

Figure 46. William Henry Jackson, A collection of buffalo, elk, deer, mountain-sheep, and wolf skulls and bones near Fort Sanders, Colorado, 1870, U.S. Geological Survey

"I do not like the idea of happiness—it is too momentary—I would say that I was always busy and interested in something—interest has more meaning to me than the idea of happyness [*sic*]."[54]

O'Keeffe's interest in shapes first led her to notice the animal bones scattered across the New Mexico landscape and decide that they had something to say about the terrain. She began collecting them, and when she returned East, she brought back a barrel of bones. This became a standard procedure during the years that she traveled between New Mexico and New York. In August 1931, writing to Rebecca Salsbury James from Lake George, O'Keeffe says, "I have been working on the trash I brought along—my bones cause much comment."[55]

One can imagine what those around her thought of this enterprise, especially if some of those bones needed cleaning. A photograph of O'Keeffe that appeared in a *Life* magazine article on February 14, 1938, shows her holding in one hand the backbone and ribcage of a cow, while in the other she grasps a horn of the head that appears to have most of the flesh and hair intact (fig. 45). She is wearing gloves, but one suspects that the head is going to need boiling down and bleaching before the skull will emerge in a pristine state ready for painting.

From descriptions and photographs of her houses at Ghost Ranch and Abiquiu, we know that the bones piled up, arranged along the walls and hung on doors and *vigas* (roof beams) (fig. 47). They were a constant reminder of what she felt about the high desert of northern New Mexico. In a statement she wrote for her exhibition at An American Place in 1939, O'Keeffe admitted: "I have wanted to paint the desert and I haven't known how. . . . So I brought home the bleached bones as my symbols of the desert. To me they are as beautiful as anything I know. To me they are strangely more living than animals walking around. . . . The bones seem to cut sharply to the center of something that is keenly alive on the desert even tho' it is vast and empty and untouchable—and knows no kindness with all its beauty."[56]

The bones were also a reminder of the role animals, wild and domestic, played in the history of the West. By the time O'Keeffe arrived in Texas in 1912, the great days of cattle raising on the plains had already passed, with the large-scale operations of the late nineteenth century reduced to more efficiently run, smaller ranches. The cattle that O'Keeffe heard and saw around Amarillo were part of this new commercial system, but memories and stories remained of the romantic days of cattle drives over the central plains and the buffalo hunts that had preceded them. The bones of these magnificent animals still turned up on land that was barely settled in O'Keeffe's youth. Hamlin Garland remembered that on his father's farm near Osage, Iowa, in the 1870s, "everywhere, in the lowlands as well as on the ridges, the bleaching white antlers of by-gone herbivora lay scattered, testifying to 'the herds of deer and buffalo' which once fed there. We were just a few years too late to see them."[57]

The evidence of those herds can be seen in William Henry Jackson's whole

plate photograph made in 1870 near Cheyenne (fig. 46). As a member of Ferdinand V. Hayden's historic survey party, Jackson documented landmarks that represented the heroic taming of the West; but as Peter Hales points out, this "is less a photograph than a trophy . . . a testimonial to the variegated species of animal in the West and an image of death."[58]

Death had come in only a few short years to the great buffalo herds, with entire eastern industries built around processing their hides, horns, hooves, and bones. By 1875 the southern herd was effectively destroyed, and by the end of 1883 the smaller northern herd was also gone.[59] The buffalo became a symbol of the lost West, memorialized like other vanished Americans on the nickel and depicted in romanticized paintings such as Henry F. Farney's *The Song of the Talking Wire* from 1904. Here a buffalo skull lies in the snow behind the Indian who has his ear to the telegraph pole in the foreground.[60]

Countless depictions of the West, in both the popular press and high art, used the skeletons of animals to symbolize the difficulties of passage into the promised land. O'Keeffe is thus not the first to equate animal bones with the western landscape, but her treatment of this subject transcends the specifics of history and the sentiments of regionalist art associated with the Taos–Santa Fe area.[61] The bones she picked up more than likely came from animals that perished of natural causes —struck by lightning, killed by predators, dead from thirst and cold or the unintentional result of livestock raising.[62] Winters in the high country of northern New Mexico and Arizona were especially hazardous for cattle, as Aldo Leopold recounts in his description of the area around White Mountain, Arizona: "There was 'The Boneyard,' a lovely meadow where bluebells arched over the half-buried skulls and scattered vertebrae of cows long since dead. Here in the 1880s a foolish cowman, newly arrived from the warm valleys of Texas, had trusted the allurements of the mountain summer and essayed to winter his herd on mountain hay. When the November storms hit, he and his horse had floundered out, but not his cows."[63]

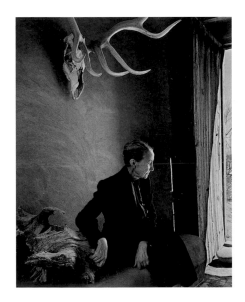

Figure 47. Yousuf Karsh, *Georgia O'Keeffe, 1956,* Courtesy Woodfin Camp & Associates, Inc.

It is appropriate, then, that O'Keeffe's depictions of bones places them in conjunction with the land the animals died on—and even more appropriate in the case of the domestic animals, the cows and sheep whose introduction to that land reshaped it. Their overgrazing contributed to erosion and the invasion of exotic plant species. Juniper and piñon expanded into what had once been grasslands, and bluegrass, yarrow, and fleabane replaced such native grasses as Thurber fescues and alpine timothy that had grown in the Sangre de Cristo Mountains of New Mexico.[64] It is doubtful that O'Keeffe knew about this ecological relationship, but in *Summer Days,* 1936 (fig. 48), the juxtaposition of deer skull, rolling barren hills, and wildflowers seems to be more than fortuitous. It is, as Marsden Hartley said, "just right."

The viewer is suspended over the landscape watching the clouds rise above the distant hills to form the towering summer thunderheads typical of the South-

west. But as the eye shifts up, the perspective snaps forward, and the flowers and skull float against a white ground that takes on the opacity of a wall. There is even the suggestion of a faint shadow cast by the deer's head. The objects in the painting have been assembled and arranged as though they were still life, yet it takes some searching to find the links to this genre in Western art. As with her earlier flower paintings, O'Keeffe has redefined the tradition.

The combination of objects with landscape has a certain precedence in earlier Flemish and French art, specifically works by François Desportes and Jean-Baptiste Oudry that combined foreground displays of food, dead game, and dogs with background views of landscape or architecture. More recent examples are the so-called trophy paintings of the late nineteenth century popularized in the United States by William Michael Harnett and his followers. Harnett's *After the*

Figure 48. *Summer Days,* 1936, oil on canvas, 36 x 30 in., Collection of the Whitney Museum of American Art, New York, Gift of Calvin Klein

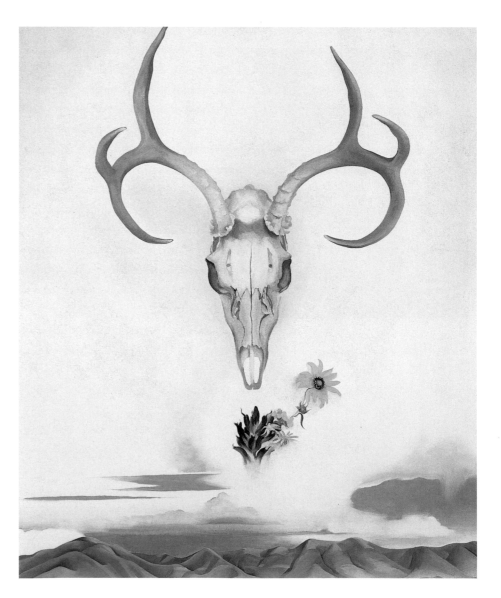

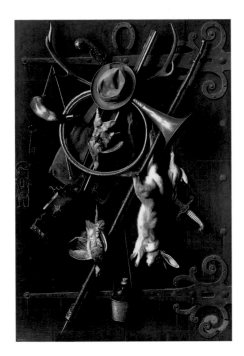

Figure 49. William M. Harnett, *After the Hunt*, 1885, oil on canvas, 71½ x 48½ in., Fine Arts Museums of San Francisco, Mildred Anna Williams Collection, 1940.93

Hunt, 1885 (fig. 49), is the most famous of these works and the one that inspired many other variations on the vertically hung game motif.[65]

The trompe-l'oeil effects that Harnett uses so skillfully give the appearance of projecting the objects into the viewer's space, while the use of light to distinguish textures and the nearly life-size scale (the work measures 71½ by 48½ inches) aid in the deception that this is the real thing. In its use of shallow vertical space and inclusion of antler trophies, this kind of painting might well have served as a prototype for O'Keeffe's skulls, but the mimetic qualities of the trompe-l'oeil tradition would not have appealed to her sensibilities. To be successful, a trompe-l'oeil artist must conceal the art that it takes to produce the trick, and this sort of self-effacement seems particularly unsuited to O'Keeffe. But more important, trompe-l'oeil could not evoke the emotional response she hoped for in the dialogue between nature and art. She needed a technique and style that truthfully acknowledged the role of the artist, conveying the power of her vision directly to the viewer.

Perhaps nowhere is that vision more clearly expressed than in *From the Faraway Nearby* (fig. 50, pl. 50). Done in 1937 and originally bearing the title *Deer's Horns Near Cameron,* this work captures the expansive emptiness of the western landscape while it suggests the exhilaration induced by that type of spatial experience. Like the skull, the viewer levitates above the ground, pulled into the ether by the repeating curves of the horns that reach out to fill the foreground of the canvas. But the horns, rendered in such a literal fashion, are not real; no deer or elk ever carried such a rack. This is instead a mythic beast, a poetic evocation of all the animals that have lived on that land. That they have also died there seems irrelevant, because this is in no way a *vanitas* painting. It is neither a contemplation of death nor a comment on the temporality of life. It is a statement about what endures, what transcends, what is eternal. And it is to O'Keeffe's credit that she can make that statement with a clarity of focus that convinces the viewer of its truth.

This ability to bring "the faraway nearby" is described beautifully by O'Keeffe's fellow artist John Marin:

These — the artists of the world — are akin to the scientists only in that their effort is to bring things near but even there they part for the scientist must need use the telescope or the microscope whereas the artist brings them near in sympathy. Their far awayness is an inducement — an all worthwhile inducement — such that cannot be laid aside so that from his very nature he brings the far away up close in loving embrace. The minute you say beautiful evening star — You have done just that — brought its far awayness right up to you. To the one without imagination the far away remains — the near remains. The one with a full imagination loses the far away and he immediately begins peopling it with his imaginings. Those things near too he pushes into the far away & brings them back with an added seeing.[66]

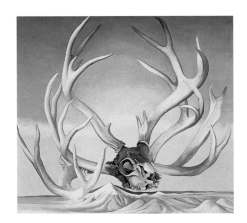

Figure 50. *From the Faraway Nearby,* 1937, oil on canvas, 36 x 40⅛ in., The Metropolitan Museum of Art, The Alfred Stieglitz Collection, 1959 (59.204.2)

Figure 51. *Pelvis with Blue (Pelvis I),* 1944, oil on canvas, 36 x 30 in., Milwaukee Art Museum, Gift of Mrs. Harry Lynde Bradley

By the early 1940s O'Keeffe's vision encompassed the pelvic bones of the animal skeletons she had been collecting. As she recalled, these bones had been lying about her house for years, "seen and not seen as such things can be—seen in many different ways. I do not remember picking up the first one but I remember from when I first noticed them always knowing I would one day be painting them."[67] She noted wryly that the pelvic bone must be as useful to the animal as its head, yet she managed to find other uses for these surprisingly graceful structures, giving them a new life in paintings that demonstrate the power of her "added seeing" (fig. 52).

Seeing is in fact one of the things they are used for, as she holds them up to frame landscape and sky. In *Pelvis with Pedernal* from 1943 (pl. 51), the distant shape of O'Keeffe's favorite mountain is balanced by the sweeping curves and intricate socket of the bone in the foreground. Light and shadow give depth and definition to the pelvis, while the flatness of the Cerro Pedernal recalls Japanese prints of Mount Fuji. It might be said that here Western chiaroscuro meets Eastern notan to suggest new ways of looking at nature and things.

The *Pelvis with Blue (Pelvis I),* 1944 (fig. 51, pl. 55), is an even more extreme combination of flat pattern with illusionistic form, a play on positive and negative space that is difficult to resolve visually. The blue shape in the center reads either as a hole or as a rounded form in front of the white. In neither case do we know what we are looking at until we are told that it is the sky seen through a section of the pelvis: bone white against blue, a framing device that O'Keeffe could have learned years earlier from William Merritt Chase, who told his students, "Hold up a card with a square hole in it and put what you see through the opening on your canvas."[68] Chase's concern with framing and the picture edge had been learned from Japanese art, something that O'Keeffe would have had reinforced through Dow's compositional theories and now freely interprets in her own way.

Equally powerful in the manipulation of vision is O'Keeffe's *Pelvis with the Distance* from 1943 (see fig. 27), a relatively small work in terms of the canvas, which measures roughly twenty-four by thirty inches, but monumental in its effect on the viewer. The pelvis structure, seen close-up and from a low perspective, assumes a towering presence over the distant mountain range. The shaded modeling of the bone's interior gives an illusion of weight and mass in spite of the lack of flesh. This, combined with the bifurcated shape, suggests a figure striding across the land—a suggestion that seems intentional on O'Keeffe's part. In the sweeping arcs of white bone and the feeling of wind moving across the flanged surfaces, one is reminded of ancient Hellenistic sculpture, specifically the famous winged *Nike of Samothrace* in the Louvre. This early second-century B.C. victory monument shows the goddess alighting on the prow of a ship, her drapery whipped dramatically back by invisible rushing air.

O'Keeffe might well have had the Nike's headless form in mind when she arranged her bones in space, but she could also have been thinking of a more

contemporary work—Umberto Boccioni's dynamic figure *Unique Forms of Continuity in Space,* 1913. The possibility of influence from both pieces is strengthened by the fact that they were included in Alfred Barr's exhibition *Cubism and Abstract Art* for the Museum of Modern Art in 1936. Barr used a plaster cast of the Nike so that he could compare the drapery with the "lines of force" in Boccioni's masterpiece, and he published photographs of both works together in the catalogue for the exhibition (figs. 53, 54).

For this show, Alfred Stieglitz loaned the museum two Picassos from his collection: the charcoal drawing *Figure* from 1910 and a *Still Life* collage of 1913. In the preface to the catalogue Barr paid homage to Stieglitz as one of the pioneers who had exhibited cubist and abstract art in the United States. Stieglitz no doubt had a copy of the catalogue, which O'Keeffe could have seen, but it is just as likely that she saw the exhibition. Although it is somewhat surprising that her

Figure 52. Michael Vaccaro, *Georgia O'Keeffe in Abiquiu, New Mexico,* April 8, 1960, Courtesy Tony Vaccaro

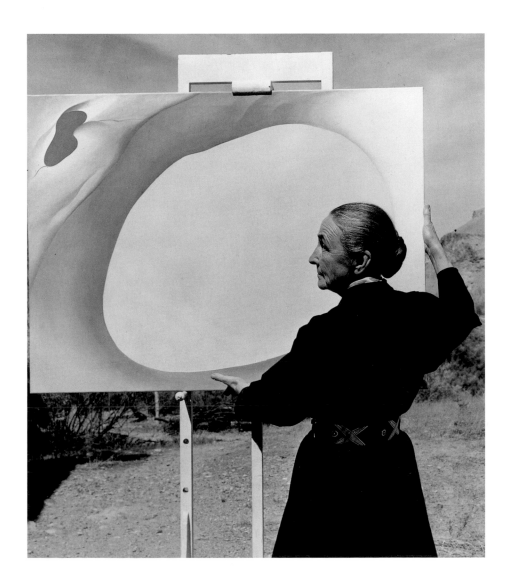

Figure 53. *Nike of Samothrace,* Greek fourth century B.C., Musée du Louvre, Paris

Figure 54. Umberto Boccioni, *Unique Forms of Continuity in Space,* 1913 (cast 1931), bronze, 43⅞ x 34⅞ x 15¾ in., The Museum of Modern Art, New York, Acquired through the Lillie P. Bliss Bequest

work was not included under the category of abstraction, the omission is understandable given that Barr was looking to Europe for the development of these artistic movements. He did include her work and that of Arthur Dove in his *Fantastic Art, Dada, Surrealism* exhibition the same year.

In 1943, when O'Keeffe began her paintings based on the animal pelvis bones, she had her first full-scale retrospective at the Art Institute of Chicago, and her recognition as an American artist with a national reputation seemed assured. Perhaps with that in mind she decided to do her own interpretation of the victory statue, casting the goddess as a stark but powerful vision in bone—an American monument with a sense of place and self equally as strong as the enlarged flowers of the 1920s, for there is little doubt that *Pelvis with the Distance* is an abstract self-portrait. What is not as certain is the symbolic meaning of the pelvis series. O'Keeffe claimed that the animal bones were symbols of the desert and nothing more. Others have seen them as emblems of death, barrenness, and isolation. Yet none of this seems appropriate in the presence of the actual paintings, which appear calm, purposeful, and austerely beautiful. Nor does interpreting them as a withering of creativity seem apropos in light of the fact that in 1946 O'Keeffe became the first woman artist granted a solo show at the Museum of Modern Art.

It is far more likely that in the extremes of the southwestern landscape O'Keeffe found a match for her own temperament and way of seeing. Her way of seeing does place demands on her viewers, but the rewards of noticing the things that she brings to our attention in her paintings are well worth the time it takes to see. This is particularly true in an age of media overload, where as Matisse observed, "To see is itself a creative operation, requiring an effort. Everything that we see in our daily life is more or less distorted by acquired habits. . . . The effort needed to see things without distortion takes something very like courage."[69] Georgia O'Keeffe had that courage.

"TO CREATE AN EQUIVALENT"

"I long ago came to the conclusion that even if I could put down accurately the thing that I saw and enjoyed, it would not give the observer the kind of feeling it gave me. I had to create an equivalent for what I felt about what I was looking at —not copy it."[70] Coming at the end of a long career, this statement, which Georgia O'Keeffe included in her "biographical catalog" in 1976, sums up what she believed she did when she painted a picture: that copying or imitating the "thing" would not produce in the viewer the same emotion she felt when she looked at the subject. It is in some ways a deceptively simple explanation for the complex issues involved in painting from nature. There have been volumes written about realism and abstraction, objectivity and nonobjectivity in art, and the theories underpinning our modern visual culture. The problem with all of this is that it is written, not seen, for as O'Keeffe knew, the meaning of a word was not as exact as the colors and shapes she used in her paintings. When she did write about her art, however, her words seem as clear and focused as the things she created with her brushes. Her own words, rather than commentary written about her, help us understand the theoretical context for her work.

It is clear from her statement that she is concerned with things looked at in the real world, not things imagined in her mind, and it is also apparent that she wants to communicate to an audience. These parameters place her work in terms of the merit of realism versus abstraction, an artistic debate current in the early part of the twentieth century when O'Keeffe developed her style. She preferred the word "objective" to "realism," and for most of her life she made little distinction between the objective and the abstract as approaches to painting, saying: "It is surprising to me to see how many people separate the objective from the abstract. Objective painting is not good painting unless it is good in the abstract sense. A hill or tree cannot make a good painting just because it is a hill or tree. It is lines or colors put together so that they say something. For me that is the very basis of painting. The abstraction is often the most definite form for the intangible thing in myself that I can only clarify in paint."[71]

By using the term "objective," O'Keeffe was literally putting distance between herself and the object she was looking at, between herself and the idea of realism, which she took to mean detailed copying or imitation of things—a notion that, when carried to the extreme in still-life painting, produced trompe l'oeil. "Objective" did not, however, mean detached or unemotional.[72] Instead, it implied that the "truth" of the thing seen and painted actually shifted toward the reality of the painting itself and, by extension, the artist's subjective emotions about the real thing that might be included in the re-presentation. This tension between the reality of things in the world and the self-reflexive reality of the painting is characteristic of Western art after Courbet and Edouard Manet, and it underlies the entire development of modernism in the twentieth century.

O'Keeffe would have encountered this dialectic shift in aesthetic thinking

during her academic training, because William Merritt Chase was talking about it when he instructed his students to go before nature and paint the "truth." But the truth was no longer mere accuracy of detail. Such skillful realism could be boring if it lacked the artist's interpretation of his or her own feeling or self-expression. Yet for Chase, self-expression could not be allowed to get the upper hand over truthful depiction; his stylistic predilection was still firmly on the side of realism, although the facture of the painting was assuming more importance than the facts of nature.

It was Arthur Wesley Dow who helped free O'Keeffe from the facts of nature and the academic tradition, whose system of composition gave her something to do with the skills she had acquired and, more important, shifted the aesthetic weight onto emotion rather than imitation as the reason for making art. For Dow the realistic standard led to the decay of art and, in the history of Western art, the divorce of representation from design. Under the influence of Eastern art and philosophy, Dow proposed a new way of thinking about composition, one that encouraged a rapprochement between representation and design but came at it from the design end, valuing "power in expression above success in drawing."[73]

This leads directly to O'Keeffe's observation about the objective versus the abstract, and to her belief that one only got at the real meaning of things through selection, elimination, and emphasis. To see what a difference this belief made for her art, we can compare her interpretation of a Penitente cross with that of Willard Nash, a Southwest regionalist artist who arrived in Santa Fe in 1920. Nash became part of a group of artists interested in Hispanic culture, particularly the Penitente rituals practiced during Lent, and his painting of *Penitentes,* c. 1930 (fig. 55), depicts hooded flagellants reenacting the Passion of Christ.

The Penitentes, commonly called Los Hermanos (The Brothers), are a lay religious society that evolved in northern New Mexico and southern Colorado during the late eighteenth century, when rural communities had no access to priests.[74] Their crosses and *moradas,* or places of worship, can be seen in the countryside between Santa Fe and Taos as well as in Abiquiu. Their rituals of penitence had attracted Anglo interest in the late nineteenth century, and O'Keeffe, like many other artists, took visual notice. After her trip to New Mexico in 1929 she did several paintings of Penitente crosses, including *Black Cross with Red Sky* (fig. 56).

Both paintings have a visual impact, but there the similarity ends. Although we get some feeling for a southwestern landscape in the Nash, the focus is on the ritual of flagellation and crucifixion and the depiction of blood on the backs of the two Penitentes. The literal representation of the event witnessed by the artist leaves the viewer searching for a narrative explanation while vicariously enjoying the sensational aspects of the ritual. For Nash the painting becomes something he saw in a specific place at a specific time, as part of the region's history. The emotional meaning of the event is found in the place, not in the painting.

Figure 55. Willard Nash, *Penitentes,* c. 1930, oil on canvas, 24 x 30 in., Collection of the Museum of the Southwest, Midland, Texas

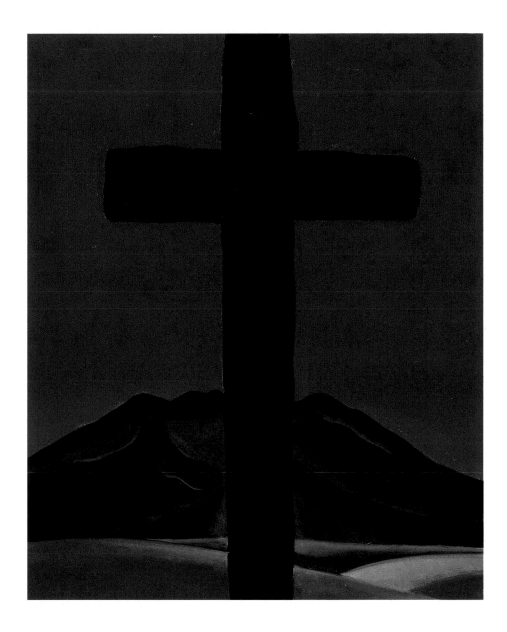

Figure 56. *Black Cross with Red Sky,* 1929, oil on canvas, 40 x 32 in., Collection of Gerald and Kathleen Peters, Santa Fe, New Mexico

O'Keeffe's black cross, in contrast, is a powerful shape in a stark landscape, recognizable as a Christian symbol but separate from specific events and location. Rather than the literal blood of Christ or the Penitentes, it is nature itself—the red sky—that could stand for the pain and suffering associated with the crucifixion and its reenactments. O'Keeffe said that she saw the crosses often and in unexpected places, "like a thin dark veil of the Catholic Church spread over the New Mexico landscape. . . . Painting the crosses was a way of painting the country."[75] We may not know that she is referring to the presence of Catholicism in the Hispanic culture of the region, but we do know how she felt about it. Her painting of the object has its roots in her emotional response to those crosses, which she conveys solely through color and shape, manipulated to make a similar

claim on the viewer. Her radical simplification or abstraction of the cross in its setting raises it to the plane of universal meaning, where it functions in the continual present.

O'Keeffe's dismissal of literal realism as inadequate for her purposes has an interesting counterpart in the ancient Pueblo perspective on representation. As Leslie Marmon Silko explains in the essay "Landscape, History, and the Pueblo Imagination": "Standing deep within the natural world, the ancient Pueblo understood the thing as it was—the squash blossom, grasshopper, or rabbit itself could never be created by the human hand. Ancient Pueblos took the modest view that the thing itself . . . could not be improved upon. . . . Thus *realism,* as we now recognize it in painting and sculpture, did not catch the imaginations of Pueblo people until recently."[76] The squash blossom itself was only one particular blossom and could not possibly represent all blossoms. Therefore the Pueblo potter abstracted what she took to be the key elements of the blossom—the four petals and the four stamens, which suggested the squash flower at the same time that it linked it with the four cardinal directions.

In its abstract form the squash blossom could signify many other relations in ancient Pueblo culture, making visible the interconnectedness of the people and their natural world. O'Keeffe in a similar manner arrived at a way of representing things that revealed her emotional connection with them. And she learned early in her career how difficult it was to control the meaning of painted images. The very personal interpretations—the Freudian and overtly sexual overtones—that critics saw in her pure abstractions of the early 1920s led her to pull back to a more objective approach in 1924. Writing to Sherwood Anderson about her upcoming exhibition, O'Keeffe explains: "My work this year is very much on the ground—There will be only two abstract things—or three at the most—all the rest is objective—as objective as I can make it. . . . I suppose the reason I got down to an effort to be objective is that I didn't like the interpretations of my other things—."[77]

So O'Keeffe returned to still life, to subjects that could be chosen, arranged, and controlled. The exhibition of 1924 contained paintings of alligator pears, calla lilies, leaves, sunflowers, red cannas, and white birches rendered in a more objective style.[78] Yet her way of painting leaves, flowers, and shells did not entirely turn aside the sexual interpretations of her work. One has only to look at her open and closed clam shells (figs. 57, 58) from 1926 to wonder what she thought the critical response would be. In the history of still-life painting the empty shell, like skulls, books, and candles, is a vanitas symbol; but it is doubtful that O'Keeffe had that in mind here. By setting the shell on end and then opening it to reveal a structure that quite obviously looks like a spermatozoon, O'Keeffe seems to be willfully challenging the critics. The intensified shadows of the shell's hinge combined with the wedge of white light at the bottom suggest a highly charged erotic symbolism. And yet, the ascetic paint surfaces with their finely modulated hues

Figure 57. *Open Clam Shell,* 1926, oil on canvas, 20 x 9 in., Private collection

Figure 58. *Closed Clam Shell,* 1926, oil on canvas, 20 x 9 in., Private collection

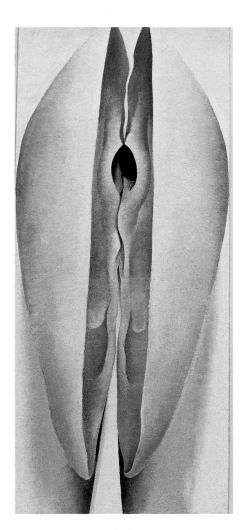

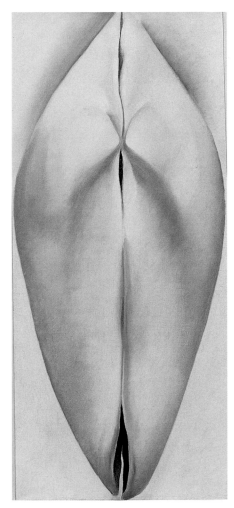

have an exquisite quality that celebrates the beauty of this natural object, which appeals to the collector in all of us.

O'Keeffe's attention to exact mixtures of colors, carefully brushed edges, and blended passages of paint indicates a concern with craftsmanship worthy of the old masters whose recipes she often followed. Paradoxically, this concern is not usually associated with modernism but instead was traditionally practiced to enhance the illusion of veristic or literal realism, to erase references to the creator of the work. Yet combined with the enlarged, close-up view of the object, O'Keeffe's technique offers an assertive brand of realism that prompts a more modern, emotional involvement with the subject, an involvement heightened by the fact that the subject is abstracted just enough to remind us that it is not solely the "thing" it purports to be. It can be many things, including a surrogate for the artist herself.

Objective abstraction gave O'Keeffe a way to make the things she represented her own, to make visible more than just the mechanical realism of a modern world that increasingly valued photographic vision. Her style could reveal the hidden realities of emotion, expression, desire, feeling—the psychological, subjective realm that painting could still call its own. Straight photography could not as easily appropriate this realm. No matter how hard Stieglitz tried, the cloud photos simply could not have the emotional impact that O'Keeffe's paintings could elicit, and the erotic feelings engendered by his pictures of her body resided ultimately in that body, not in the photographs. Stieglitz, as photographer, could not in fact "own" the subjects he shot; he could only refer to them in the real world, while O'Keeffe, who made her subjects out of oil on canvas, and made them uniquely to match her vision of the world, did truly own her things.

Did O'Keeffe think of her art in this fashion? The plainness of her things has suggested to some critics a strain of anti-intellectualism, or a disinterest in theory and intellectual constructs. More likely, it was a recognition on her part that she could not function as an artist if she thought that way. O'Keeffe's strength lies in the fact that she remains visual, wedded to the belief that color and shape can say more about her world than words can. In her best work she creates a synthesis of nature, the object, and the self. She maintains a delicate balance between the objective and the abstract that keeps the work in the present and always accessible. At that point, her "things" simply *are,* and they encourage looking and contemplation rather than thought and analysis.

Whether the flower or the color is the focus I do not know. I do know that the flower is painted large to convey to you my experience of the flower — and what is my experience of the flower if it is not color.

GEORGIA O'KEEFFE

TO WILLIAM MILLIKEN, 1930

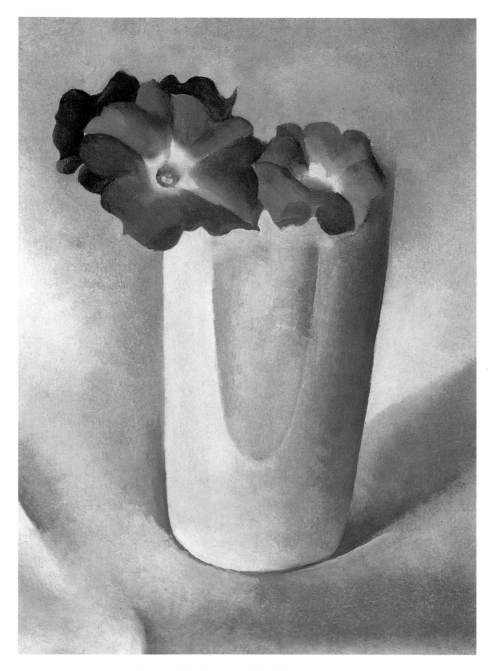

Plate 20. *Pink Petunias in White Glass,* 1924,
oil on canvas, 10 x 7 in., Gerald Peters Gallery,
Santa Fe, New Mexico

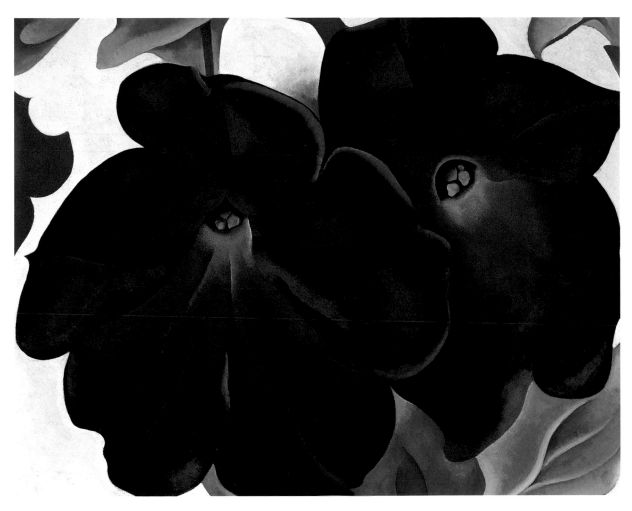

Plate 21. *Black and Purple Petunias,* 1925, oil on canvas,
20 x 25 in., Maryellie Johnson

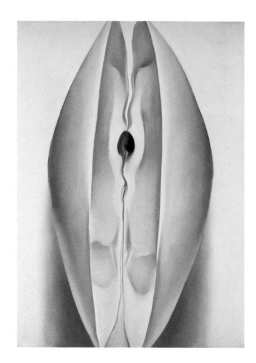

Plate 27. *Slightly Open Clam Shell,* 1926, pastel on paperboard, 18½ x 13 in., Curtis Galleries, Minneapolis, Minnesota

Plate 28. *Shell and Old Shingle No. II,* 1926, oil on canvas, 30¼ x 18⅛ in., Museum of Fine Arts, Boston, Alfred Steglitz Collection, Bequest of Georgia O'Keeffe 1987.536

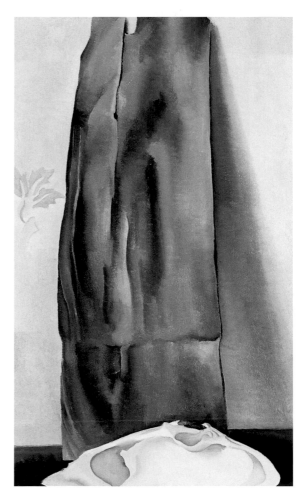

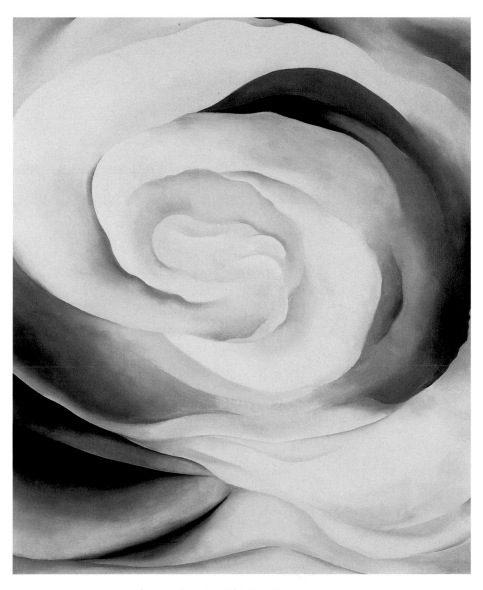

Plate 29. *Abstraction, White Rose II,* 1927,
oil on canvas, 37½ x 31 in., The Georgia O'Keeffe
Museum, Santa Fe, New Mexico; Gift of
The Burnett Foundation and The Georgia
O'Keeffe Foundation

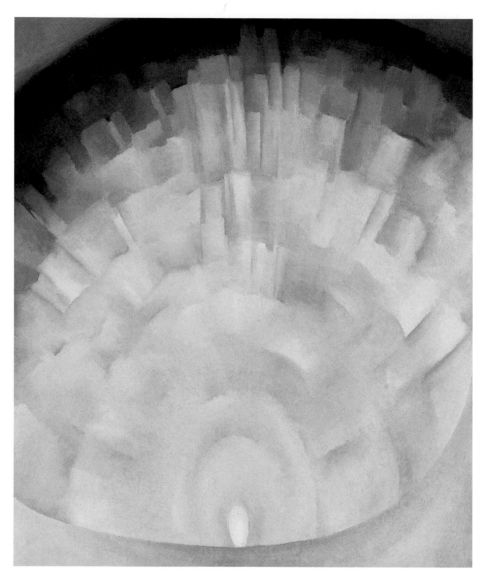

Plate 30. *Abstraction, White Rose III*, 1927, oil on canvas, 36 x 36 in., The Art Institute of Chicago, Alfred Stieglitz Collection, Bequest of Georgia O'Keeffe 1987.250.1

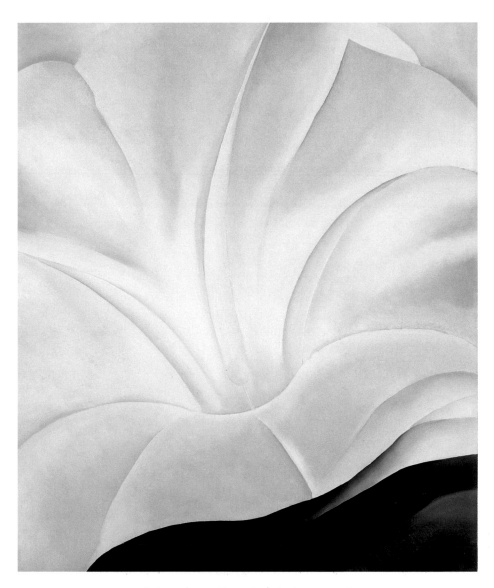

Plate 31. *Morning Glory with Black, No. 3,* 1926, oil on
canvas, 35⅞ x 29¾ in., The Cleveland Museum of Art,
Bequest of Leonard C. Hanna, Jr. 1958.42

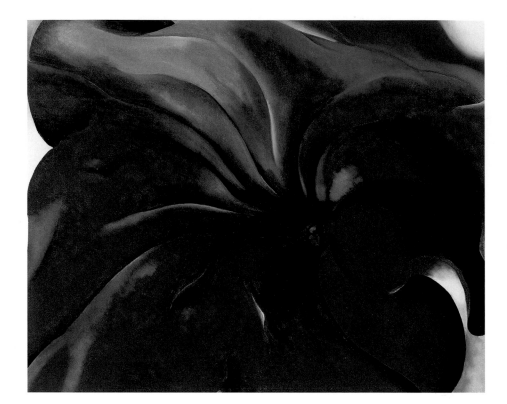

Plate 32. *Purple Petunia,* 1927, oil on canvas,
30 x 36 in., Collection of Mr. and Mrs. Graham Gund

Plate 33. *Poppy,* 1927, oil on canvas, 30 x 36 in.,
Museum of Fine Arts, St. Petersburg, Florida; Gift
of Charles and Margaret Stevenson Henderson in
memory of Jeanne Crawford Henderson

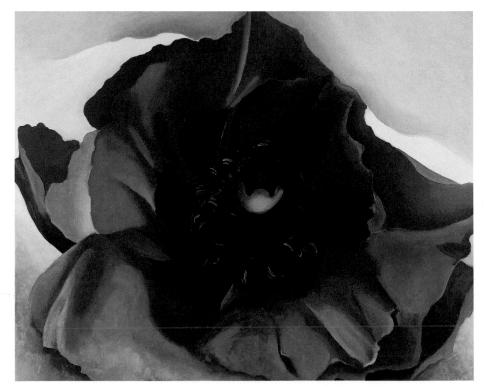

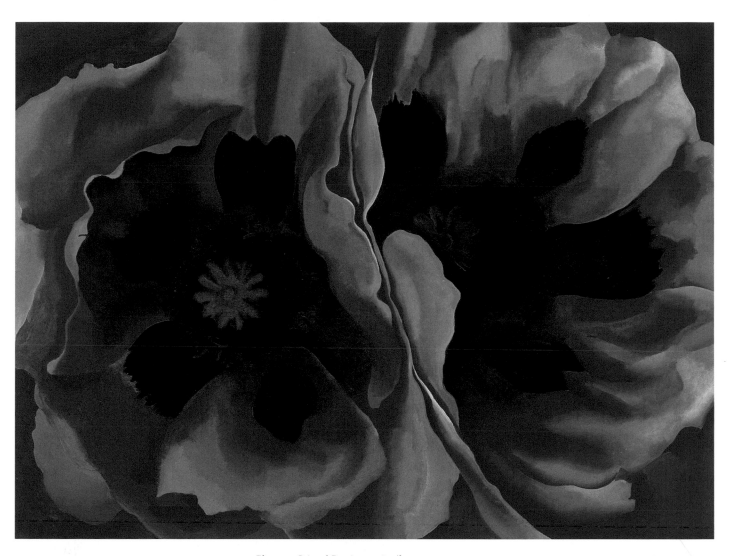

Plate 34. *Oriental Poppies,* 1928, oil on canvas,
30 x 40⅛ in., Lent by the Frederick R. Weisman Art
Museum, University of Minnesota, Museum Purchase

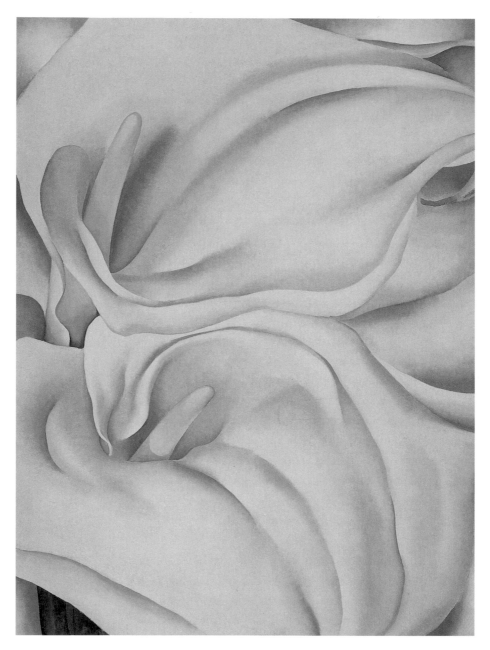

Plate 35. *Two Calla Lilies on Pink,* 1928, oil on canvas,
40 x 30 in., Philadelphia Museum of Art, Bequest of
Georgia O'Keeffe for the Alfred Stieglitz Collection

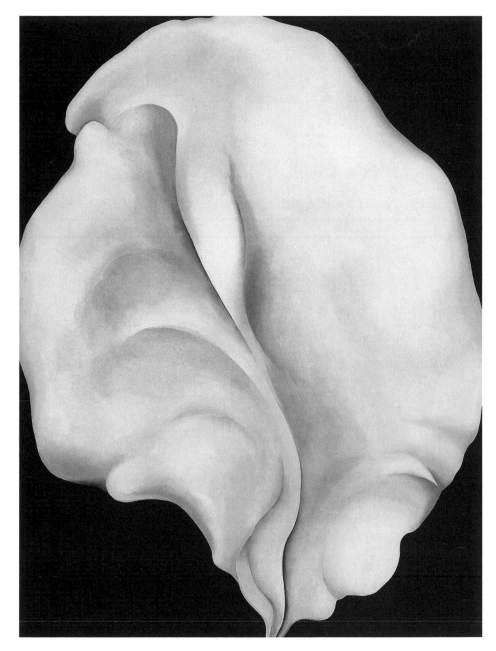

Plate 36. *Shell on Red,* 1931, oil on canvas,
40 x 30 in., Private collection

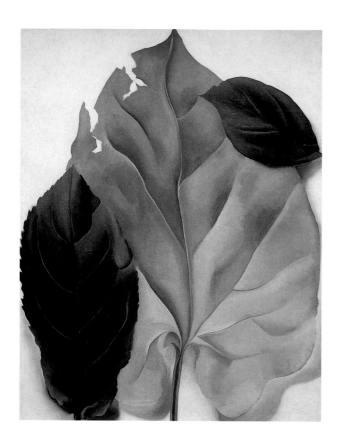

Plate 39. *Brown and Tan Leaves,* 1928, oil on canvas, 40 x 29⅞ in., Collection of Gerald and Kathleen Peters, Santa Fe, New Mexico

Plate 40. *My Autumn,* 1929, oil on canvas, 40 x 30 in., Hughes and Sheila Potiker

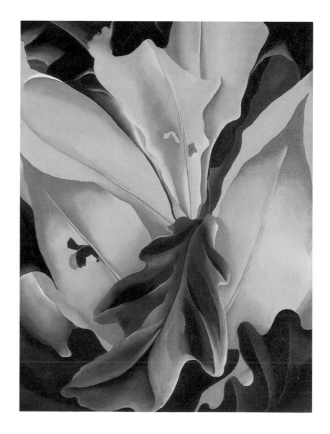

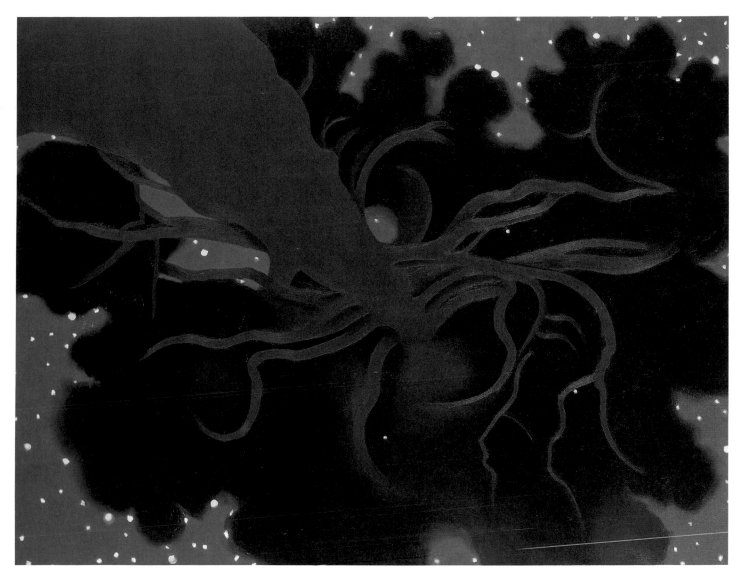

Plate 41. *The Lawrence Tree,* 1929, oil on canvas,
31 x 40 in., Wadsworth Atheneum, Hartford,
The Ella Gallup Sumner and Mary Catlin Sumner
Collection Fund

1930

FEBRUARY 7–MARCH 17: Twenty-seven paintings that introduce her latest New Mexican subjects—Penitente crosses, adobe churches, landscapes, abstractions, and still lifes—are shown at An American Place in the first of her annual exhibitions, which continue through 1946. SPRING: Defends the social content of her art in a public debate with Michael Gold, editor of the populist *New Masses:* "I have no difficulty in contending that my paintings of a flower may be just as much a product of this age as a cartoon about the freedom of women—or the working class—or anything else."[46] MAY: Begins exploring the jack-in-the-pulpit flower, which results in a series of six paintings (see figs. 21, 22, pls. 42, 43). In mid-June, returns to Taos as Luhan's guest.

1931

APRIL 14: The Whitney Museum of American Art purchases its first work by O'Keeffe. APRIL–JULY: During her third visit to New Mexico, travels to Alcalde, forty miles southwest of Taos, where she rents a cottage on the H & M Ranch of Henwar Rodakiewicz and Marie Garland. Drives in her Model A Ford "almost daily out from Alcalde toward a place called Abiquiu—painting and painting. I think I never had a better time painting—and never worked more steadily and never loved the country more."[47] JULY: Returns to Lake George and begins painting bones and skulls from the barrel she had shipped back East from New Mexico this year or possibly in 1930 (fig. 73). Says of her new work, "My paintings hang on the wall and look funny to me—What I do here [rather than in New Mexico] is very different—but that was my intention."[48] DECEMBER 2–FEBRUARY 11, 1932: Presents her bone paintings for the first time at An American Place. Critic Henry McBride sees them "merely as elegant shapes charged with solemn mystery." Assessing her own work, she says, "The landscapes and the bones were both in a very objective stage of development—I hadn't worked on the landscapes at all after I brought them in from outdoors—so that memory or dream thing I do that for me comes nearer reality than my objective kind of work—was quite lacking."[49]

1932

SPRING: Despite Stieglitz's protestations, accepts a fifteen-hundred-dollar commission from Radio City Music Hall to paint a mural. That fall, because of technical problems with the fixative for the canvas, she abandons the project. Her health subsequently begins to deteriorate. AUGUST–EARLY SEPTEMBER: Accompanied by Georgia Engelhard, travels to the Gaspé Peninsula in Canada, her first trip outside the United States. Paints constantly with Engelhard, one of the few people other than her sister Catherine with whom she is willing to work. The two return to Canada several times this year. There she paints crosses, barns, and landscapes.

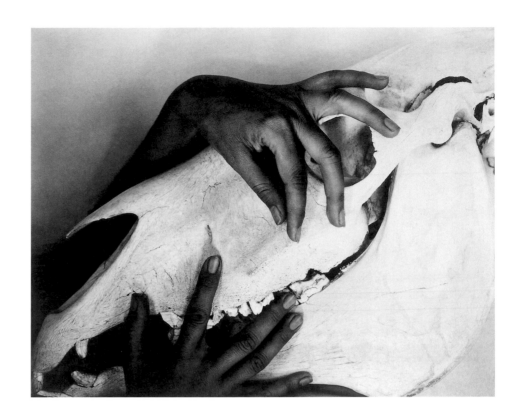

Figure 73. Alfred Stieglitz, *Georgia O'Keeffe*, c. 1930, gelatin silver print, 7⅞ x 9⅞ in., The Metropolitan Museum of Art, Gift of Georgia O'Keeffe through the generosity of The Georgia O'Keeffe Foundation and Jennifer and Joseph Duke, 1997 (1997.61.37)

1933

JANUARY 7–MARCH 18: *Paintings New & Some Old* opens at An American Place, including work from 1927 to 1932. For McBride, her paintings appear "to be wished upon the canvas [T]he mechanics have been . . . so successfully concealed."[50] FEBRUARY 1: Enters Doctors Hospital in New York City and is treated for psychoneurosis. Her long convalescence halts her ability to work for the rest of the year. On March 24, she is discharged from the hospital and goes to Bermuda to recuperate with friend Marjorie Content and her daughter, staying through May. DECEMBER: Alone at Lake George, O'Keeffe invites writer Jean Toomer, a friend of hers and Stieglitz's since the early 1920s, to visit. His company revives her: "You seem to have given me a strangely beautiful feeling of balance."[51]

1934

EARLY JANUARY: Resumes painting, reflecting, "My center does not come from my mind—it feels in me like a plot of warm moist well-tilled earth with the sun shining hot on it. . . . It seems I would rather feel it starkly empty than let anything be planted that can not be tended to the fullest possibility of growth."[52] JANUARY 29–MARCH 17: Oversees the hanging of her retrospective at An American Place, including forty-four paintings from 1915 to 1927. "The directness of transcription from feeling to symbol," writes critic Lewis Mumford, "gives the

Plate 44. *Cross by the Sea, Canada, 1932,* oil on canvas,
36 x 24 in., The Currier Gallery of Art, Manchester,
New Hampshire; Currier Funds

Plate 45. *Gray Cross with Blue,* 1929, oil on canvas,
36 x 24 in., Collection of The Albuquerque Museum;
Museum purchase with funds from 1983–85 General
Obligation Bonds, The Frederick R. Weisman
Foundation, Ovenwest Corp., and The Albuquerque
Museum Foundation

Plate 49. *Fishhook from Hawaii No. I,* 1937, oil on
canvas, 18 x 14 in., Brooklyn Museum of Art, Bequest
of Georgia O'Keeffe

Plate 50. *From the Faraway Nearby,* 1937, oil on canvas,
36 x 40⅛ in., The Metropolitan Museum of Art, The Alfred
Stieglitz Collection, 1959 (59.204.2)

Plate 51. *Pelvis with Pedernal,* 1943, oil on canvas,
16 x 22 in., Munson–Williams–Proctor Institute
Museum of Art, Utica, New York, 50.19

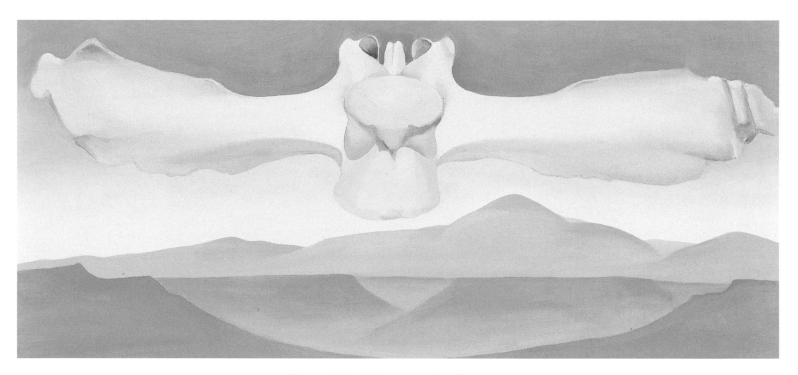

Plate 52. *Flying Backbone,* 1944, oil on fabric,
12 x 26 in., The Alfred Stieglitz Collection of
Modern Art, Fisk University, Nashville,
Tennessee; Gift of Georgia O'Keeffe

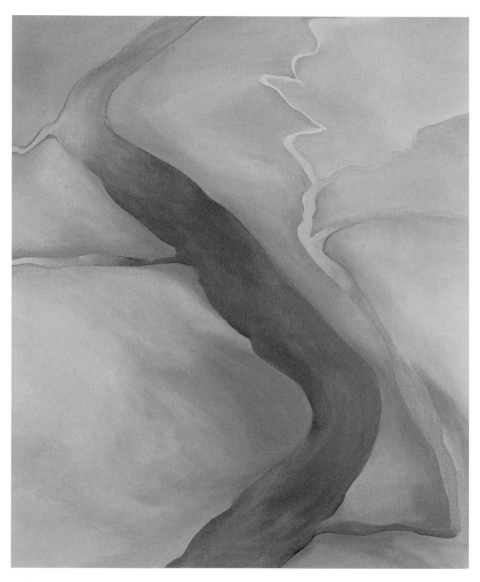

Plate 53. *It Was Yellow and Pink II,* 1959, oil on canvas, 36 x 30 in., The Cleveland Museum of Art, Bequest of Georgia O'Keeffe 1987.137

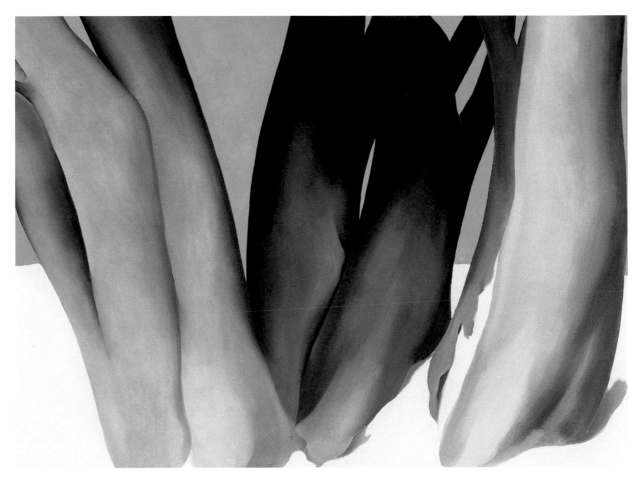

Plate 54. *Bare Tree Trunks with Snow,* 1946, oil on
canvas, 29½ x 39½ in., Dallas Museum of Art, Dallas
Art Association Purchase 1953.1

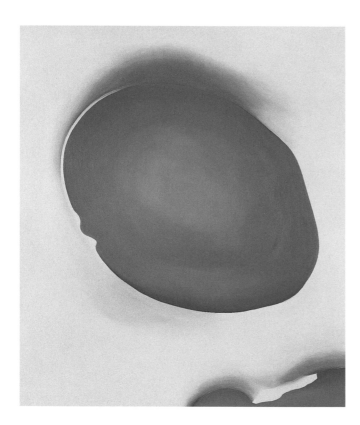

Plate 55. *Pelvis with Blue (Pelvis I),* 1944, oil on canvas, 36 x 30 in., Milwaukee Art Museum, Gift of Mrs. Harry Lynde Bradley

Plate 56. *Pelvis Series, Red with Yellow,* 1945, oil on canvas, 36⅛ x 48⅛ in., The Georgia O'Keeffe Museum, Santa Fe, New Mexico; Extended Loan, Private collection

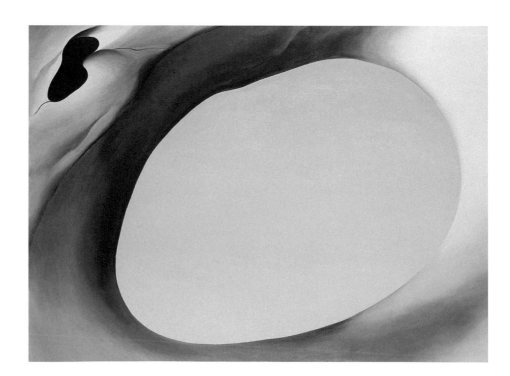

Plate 57. *Ladder to the Moon*, 1958, oil on canvas,
40 x 30 in., Collection Emily Fisher Landau, New York

Plate 58. *Patio with Black Door,* 1955, oil on canvas, 40 x 30 in., Museum of Fine Arts, Boston, Gift of the William H. Lane Foundation 1990.433

Plate 59. *My Last Door,* 1954, oil on canvas, 48 x 84 in., The Georgia O'Keeffe Museum, Santa Fe, New Mexico; Gift of The Burnett Foundation

Plate 60. *In the Patio #1*, 1946, oil on paper adhered
to a paperboard support, 29¼ x 23¾ in.,
San Diego Museum of Art, Gift of Mr. and
Mrs. Norton S. Walbridge

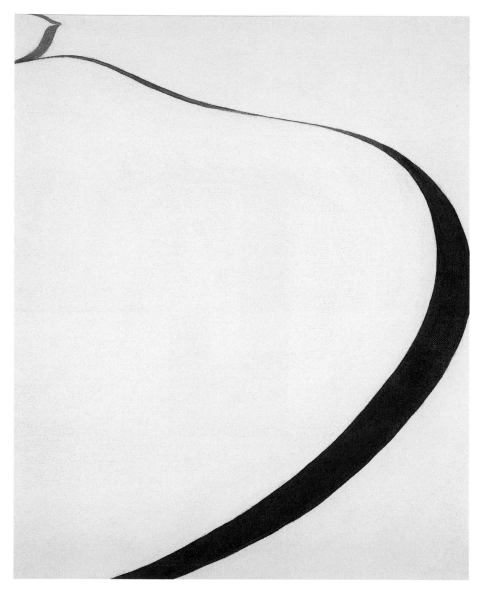

Plate 61. *Winter Road I,* 1963, oil on canvas,
22⁄₁₆ x 18⁄₈ in., National Gallery of Art,
Washington, D.C.; Gift of The Georgia
O'Keeffe Foundation 1995.4.1

*Two walls of my room in the Abiquiu house are glass
and from one window I see the road toward Espanola,
Sante Fe and the world. The road fascinates me with
its ups and downs and finally its wide sweep as it speeds
toward the wall of my hilltop to go past me. I had made
two or three snaps of it with a camera. For one of them
I turned the camera at a sharp angle to get all the road.
It was accidental that I made the road seem to stand up
in the air, but it amused me and I began drawing and
painting it as a new shape. The trees and mesa beside
it were unimportant for that painting — it was just
the road.*

GEORGIA O'KEEFFE, 1976

notes

the real meaning of things

1 "I Can't Sing, So I Paint! Says Ultra Real-
 istic Artist; Art Is Not Photography — It Is
 Expression of Inner Life!: Miss O'Keeffe
 Explains Subjective Aspect of Her Work,"
 New York Sun, Dec. 5, 1922, 22, quoted
 in Barbara Buhler Lynes, *O'Keeffe,
 Stieglitz, and the Critics, 1916–1929* (Ann
 Arbor, Mich., 1989), 180.

2 Georgia O'Keeffe, *Georgia O'Keeffe* (New
 York, 1976), n.p. (opposite pl. 31).

3 Katherine Kuh, "Georgia O'Keeffe," in
 Kuh, *The Artist's Voice: Talks with Seven-
 teen Artists* (New York, 1962), 190.

4 Barbara Rose was one of the first art his-
 torians to posit Fenollosa through Dow
 and later through the poets in the Stieglitz
 circle as the missing link for O'Keeffe's
 interest in transcendentalist thought and
 Far Eastern art. See Barbara Rose,
 "O'Keeffe's Trail," *New York Review,*
 Mar. 31, 1977, 30; Sarah Whitaker Peters
 has demonstrated Dow's continuing
 influence upon O'Keeffe and has con-
 nected images in Dow's *Composition* with
 O'Keeffe's paintings through the 1920s.
 See Peters, *Becoming O'Keeffe: The Early
 Years* (New York, 1991), 82–100, 258–59,
 262–63; for a discussion of Dow's precepts
 in O'Keeffe's approach to landscape and
 architectural subjects, see Sharyn Udall,
 O'Keeffe and Texas, exh. cat., Marion
 Koogler McNay Art Museum (San Anto-
 nio, 1998), 15–29, 55–61.

5 Whether Dow met Paul Gauguin is
 debatable. For a discussion of Dow in
 Pont Aven, see Frederick C. Moffatt,
 Arthur Wesley Dow, 1857–1922 (Washing-
 ton, D.C., 1977), 24–29.

6 Arthur Wesley Dow, *Composition: A Series
 of Exercises in Art Structure for the Use of
 Students and Teachers,* introduction by
 Joseph Masheck (1913; reprint, Berkeley,
 Calif., 1997), 97.

7 Dow, *Composition,* 79.

8 Fenollosa's poem "The Future Union of
 East West" envisioned a universal culture:

"Within the coming century the blended
strength of Scientific Analysis and Spiritual
Wisdom should wed for eternity the
blended grace of Aesthetic Synthesis and
Spiritual Love." See Rick Fields, *How the
Swans Came to the Lake: A Narrative His-
tory of Buddhism in America* (Boulder,
Colo., 1981), 155.

9 I thank Howard Singerman for permitting
 me to read his manuscript "Making
 Artists: the Discipline of Art in the Ameri-
 can University," forthcoming from the
 University of California Press, which dis-
 cusses "Dow's power."

10 Dow, *Composition,* 177.

11 Arthur Wesley Dow, "The Responsibility
 of the Artist as Educator," *Lotos,* February
 1896, p. 611.

12 For more on the national lecture tours of
 Dow and Fenollosa see Moffatt, *Dow,* 50,
 91, 106; Lawrence W. Chisolm, *Fenollosa:
 The Far East and American Culture* (New
 Haven, 1963), 158–64; and Dorothy Jean
 Hook, "Fenollosa and Dow: The Effect of
 an Eastern and Western Dialogue on
 American Art Education" (Ph.D. diss.,
 Pennsylvania State University, 1987),
 179–87.

13 Roxana Robinson, *Georgia O'Keeffe: A
 Life* (New York, 1989), 90–91.

14 Mary Lynn Kotz, "A Day with O'Ke-
 effe," *Art News,* December 1977, quoted
 in Robinson, *O'Keeffe,* 90.

15 Max Weber, *Essays on Art* (New York,
 1916), 32, 35–36, quoted in Chisolm,
 Fenollosa, 236; see also Max Weber's
 memoir cited in Moffatt, *Dow,* 143.

16 For the reading list see Moffatt, *Dow,* 107.

17 Ernest Fenollosa, *Epochs of Chinese and
 Japanese Art: An Outline History of East Asi-
 atic Design,* 2 vols., edited by Mary Fenol-
 losa (1912; rev. ed. New York, 1921), 6.

18 Dow wrote, "It is now plain to me that
 Whistler and Pennell whom I have
 admired as great originals are only copying
 the Japanese. One evening with Hokusai

gave me more light on composition and decorative effect than years of study of pictures" (Johnson, "Notes on Dow's Letters," Feb. 27, 1891, quoted in Moffatt, *Dow,* 48–49).

19 Arthur W. Dow, "Modernism in Art," c. 1915, Dow Papers, Archives of American Art (AAA), Smithsonian Institution, Washington, D.C., reel 1033, frame 1326.

20 O'Keeffe, *O'Keeffe,* n.p. (opposite pl. 14).

21 Dow hired Charles Martin to lend a more modern emphasis to the program. See Arthur Wesley Dow, *Teacher's College Record* 16 (September 1915), 88, cited in Moffatt, *Dow,* 150.

22 Ezra Pound, *Gaudier-Brzeska: A Memoir* (1916, reprint New York, 1960), quoted in Hugh Kenner, *The Pound Era* (Berkeley, Calif., 1971), 256; O'Keeffe, "I Can't Sing, So I Paint!" quoted in Lynes, *O'Keeffe,* 180.

23 Wassily Kandinsky, *Concerning the Spiritual in Art,* translated by M. T. H. Sadler (New York, 1977), 35.

24 Dow, *Composition,* 177.

25 O'Keeffe to Anita Pollitzer, October 1915, in Pollitzer, *Lovingly, Georgia: The Complete Correspondence of Georgia O'Keeffe and Anita Pollitzer,* edited by Clive Giboire, introduction by Benita Eisler (New York, 1990), 59.

26 Dow, *Composition,* 156.

27 Ibid., 74.

28 O'Keeffe to Pollitzer, October 1915, in Pollitzer, *A Woman on Paper: Georgia O'Keeffe* (New York, 1988), 29.

29 The possibility that art could be made to speak to the soul like music, without benefit of subject or narrative, had captivated American artists since Whistler. Dow through Fenollosa came to understand the idea as "visual music." See Dow, *Composition,* 65.

30 *Blast,* 1914, quoted in Kenner, *Pound Era,* 146.

31 See Marius de Zayas, *Alfred Stieglitz,* April 1914, reproduced in *Camera Work* no. 46 (October 1914), 37.

32 Pollitzer to O'Keeffe, Jan. 1, 1916, in Pollitzer, *Lovingly, Georgia,* 115–16.

33 Herbert J. Seligmann, *Alfred Stieglitz Talking: Notes on Some of His Conversations, 1926–1931* (New Haven, 1966), 44.

34 Alon Bement to O'Keeffe, Feb. 10, 1916, Yale Collection of American Literature, Beinecke Rare Book and Manuscript Library, Yale University (hereafter YCAL). See Fenollosa's quotation of Kakki: "A great thorough-going man does not confine himself to one school; but combines many schools, . . . thereby forming a style of his own; and then, for the first time he can say that he has

become an artist" (Fenollosa, *Epochs,* 15).

35 O'Keeffe to Pollitzer, January 1917, in Pollitzer, *Lovingly, Georgia,* 238.

36 O'Keeffe's reading of Willard Huntington Wright's *The Creative Will: Studies in the Philosophy and the Syntax of Aesthetics* (London, 1916) in 1916 corroborates Dow. Wright favorably reviewed the reprinted edition of *Composition* in 1913, finding it a palatable idea of artistic reform because of its adherence to craftsmanship and recommended it for art students (Wright, "Review of *Composition* by Arthur Dow," "Fresh Literature" page, *Los Angeles Times,* Mar. 1, 1913, quoted in Marilyn Claire Baker, "The Art Theory and Criticism of Willard Huntington Wright" [Ph.D. diss., University of Wisconsin-Madison, 1975]), 109.

37 Dow, *Composition,* 63.

38 Georgia O'Keeffe, *Georgia O'Keeffe: A Portrait by Alfred Stieglitz* (New York, 1978), 10.

39 O'Keeffe to Pollitzer, August 1916, in Pollitzer, *Lovingly, Georgia,* 174.

40 O'Keeffe to Pollitzer, October 1915, in ibid., 46.

41 Arthur Wesley Dow to O'Keeffe, Apr. 24, 1917, YCAL.

42 Peters first interpreted this photo as depiction of O'Keeffe as Dow's student; see Peters, *Becoming O'Keeffe,* 92.

43 Van Gogh wrote to his sister, Wilhelmina J. van Gogh, "For my part I don't need Japanese pictures here, for I am always telling myself that here I am in Japan. Which means that I have only to open my eyes and paint what is right in front of me, if I think it effective" (Letter w 71, *The Complete Letters of Vincent van Gogh,* vol. 3 [Boston: New York Graphic Society], 1981, 443). I thank Johanna Halford MacLoud for this reference.

44 Ruth E. Fine, Elizabeth Glassman, and Juan Hamilton, *The Book Room: Georgia O'Keeffe's Library in Abiquiu,* with catalogue entries by Sarah Burt, exh. cat., The Georgia O'Keeffe Museum and The Grolier Club (Abiquiu, N.Mex., 1997), 62.

45 Dow, *Composition,* 73.

46 Ibid., 122.

47 O'Keeffe to Pollitzer, October 1915, in Pollitzer, *Lovingly, Georgia,* 28.

48 Dow, *Composition,* 73.

49 Georgia O'Keeffe, "To MSS. and Its 33 Subscribers and Others Who Read and Don't Subscribe!" letter to the editor, *MSS.,* no. 4 (December 1922), 17–18, quoted in Lynes, *O'Keeffe,* 182.

50 Beatrice Irwin's *New Science of Color* (San Francisco, 1915) was in O'Keeffe's possession in the fall of 1915. See Fine, Glass-

man, and Hamilton, *Book Room,* 39. Beatrice Irwin, a member of the Bahai Faith, called herself a "chromotologist" and a performing artist. She gave recitals of poetry (both ancient and her own "color poems") in New York and London wearing oriental costumes; she performed in front of a set designed to represent "nature's color waves" while colored lights flashed upon her. See The Universal House of Justice, *The Bahai World: An International Record* (Haifa, Israel, 1970), 882–84.

51 A precedent for O'Keeffe's research pertaining to abstraction and photography may be found in Oscar Bluemner, a habitué of 291 and an artist who greatly interested Wright. "Bluemner is a serious searcher after reality," Wright wrote. "For this, let us praise him. He is working out a problem which he says will take him 20 years to solve. His problem is to express by abstract means, an almost photographic representation of nature's effect on us" (Willard Huntington Wright, *Modern Painting: Its Tendency and Meaning* [New York, 1915], 57, quoted in Baker, *Willard Huntington Wright,* 205).

52 This idea may have come from Wright. See his assertion that "the deeper facts of art and the deeper facts of life (the two being synonymous) can be tested by the forces, construction, poise, plasticity, needs, laws, reactions, harmonies, growth, forms and mechanism of the body" (*Creative Will,* 11).

53 Marsden Hartley, *Adventures in the Arts* (New York, 1921), 117.

54 Henry David Thoreau, *Walden, or Life in the Woods,* edited by Christopher Bigsby (Rutland, Vt., 1995), 243.

55 Barbara Rose cites Fenollosa as the missing link between the artists of the Stieglitz circle and the Transcendentalists. See Rose, "O'Keeffe's Trail," 31. Sarah Whitaker Peters asserts the primary influence of Mallarmé and other symbolist poets so often quoted in *Camera Work.* See Peters, *Becoming O'Keeffe,* 68.

56 Fenollosa died in London in 1908, leaving much of his work unpublished. Fenollosa's *Epochs of Chinese and Japanese Art* was completed and published posthumously in 1912 through the efforts of his second wife, Mary, and Laurence Binyon. In 1913 Mary Fenollosa sent her husband's remaining manuscripts concerning Chinese poetry and No drama to Ezra Pound in London. Pound was in touch with poets of the Stieglitz circle through Glebe, a journal published by Alfred Krembourg and painter-photographer Man Ray. Pound was also affiliated with such poetry

magazines as *Others* and *Broom*. Pound did not actually translate the poems in Cathay so much as adapt Fenollosa's transcriptions of translations made by Mori Kainen and other scholars. My thanks to Ellen Conant for bringing this information to my attention.

57 Louis Martz, "Pound's Early Poems," in *Modern Critical Views of Ezra Pound*, edited by Harold Bloom (New York, 1987), 72.

58 William Carlos Williams, "A Sort of Song," in *William Carlos Williams: Selected Poems*, edited by Charles Tomlinson (New York, 1985), 145.

59 Ernest Fenollosa, *The Chinese Written Character as a Medium for Poetry: An Ars Poetica*, edited by Ezra Pound (New York, 1936), 26, quoted in Chisolm, *Fenollosa*, 226.

60 O'Keeffe wrote, "I found that I could say things with color and shapes that I couldn't say in any other way—things that I had no words for" (O'Keeffe, Exhibition Statement, Anderson Galleries, 1923, quoted in Lynes, *O'Keeffe*, 68).

61 Paul Rosenfeld, "American Painting," *Dial*, Dec. 1, 1921, quoted in ibid., 171.

62 Helen Appleton Read, "Georgia O'Keeffe," *Brooklyn Daily Eagle*, Jan. 16, 1927, 6E, quoted in ibid., 260–61.

63 "Extracts from the Famous Essay by Kakki (Kuo Hsi) on Painting," in Fenollosa, *Epochs*, 17.

64 O'Keeffe to Sherwood Anderson, Feb. 11, 1924, in Jack Cowart, Juan Hamilton, and Sarah Greenough, *Georgia O'Keeffe: Art and Letters*, exh. cat., National Gallery of Art (Washington, D.C., 1987), 154.

65 Georgia O'Keeffe, "About Myself," *Georgia O'Keeffe Exhibition of Oils and Pastels* (New York: An American Place, 1939), n.p.

66 Waldo Frank, "White Paint and Good Order," chap. 3 in *Time Exposures* (New York, 1926), 31–35, quoted in Lynes, *O'Keeffe*, 253.

67 Frances O'Brien, "Americans We Like: Georgia O'Keeffe," *Nation*, Oct. 12, 1927, 361–62, quoted in ibid., 269.

68 "Extracts from the Famous Essay by Kakki," in Fenollosa, *Epochs*, 17–18.

69 Alfred Stieglitz to Marie Rapp Boursault, Oct. 6, 1920, YCAL, quoted in Robinson, *O'Keeffe*, 233; Stieglitz to Paul Rosenfeld, Nov. 23, 1923, YCAL.

70 Blanche C. Matthias, "Georgia O'Keeffe and the Intimate Gallery: Stieglitz Showing Seven Americans," *Chicago Evening Post Magazine of the Art World*, Mar. 2, 1926, 14, quoted in Lynes, *O'Keeffe*, 246–50.

71 Fenollosa, "Chinese Written Character," quoted in Chisolm, *Fenollosa*, 226.

72 Dow, *Composition*, 129.

73 Dow's exercises often called for students to cut the space of an image in several ways. In his introduction to Dow, *Composition*, editor Joseph Masheck compares Dow's method to that of the filmmaker; see Masheck, "Dow's Way to Modernity for Everybody," 41, 130–32.

74 Charles Demuth, statement in *Georgia O'Keeffe: Paintings, 1926* [exh. cat., Intimate Gallery], quoted in Lynes, *O'Keeffe*, 258.

75 Lillian Sabine, "Record Price for Living Artist: Canvases of Georgia O'Keeffe Were Kept in Storage for Three Years Until Market Was Right for Them," *Brooklyn Sunday Eagle Magazine*, May 27, 1928, 11, quoted in ibid., 288.

76 "I was an outsider. My color and form were not acceptable. It had nothing to do with Cézanne or anyone else. I didn't understand what they were talking about—why one color was better than another. I never did understand what they meant by 'plastic'" (O'Keeffe, *O'Keeffe*, 59).

77 Edmund Wilson, "The Stieglitz Exhibition," *New Republic*, Mar. 18, 1925, 97–98, quoted in Lynes, *O'Keeffe*, 258.

78 Murdock Pemberton, in "The Art Galleries: Those of You Who Have Heard This Story, Please Be Good Enough to Step Out of the Room," *New Yorker*, Jan. 22, 1927, 62–63 (review of the exhibition *Georgia O'Keeffe: Paintings, 1926*, The Intimate Gallery, New York, Jan. 11–Feb. 27, 1927), quoted in Lynes, *O'Keeffe*, 261–62.

79 Pemberton quoted in ibid., 261–62.

80 Barbara Lynes's analysis of the critical reception of O'Keeffe's paintings during the 1920s demonstrates how much O'Keeffe consciously developed in response to unwanted sexual allusions in the press. See Lynes, *O'Keeffe*, 3–164.

81 Wright, note written at the request of S. S. Van Dine and given to Mitchell Kennerly, Mitchell Kennerly Papers, Rare Books and Manuscript Division, New York Public Library, 1928. The purported sale later proved to be a major publicity stunt of Stieglitz's.

82 Christine Taylor Patten and Alvaro Cardona-Hine, "Days with O'Keeffe," *Art News* 91, no. 4 (April 1992), 109.

83 Sabine, "Record Price for Living Artist," 11, quoted in Lynes, *O'Keeffe*, 288–91.

84 Stieglitz to Arthur Dove, Mar. 1, 1929, Dove Papers, AAA; Stieglitz to Marsden Hartley, Feb. 5, 1929, quoted in Lynes, *O'Keeffe*, 343; O'Keeffe to Henry McBride, February 1929, quoted in Cowart, Hamilton, and Greenough, *Art and Letters*, 187–88.

85 O'Keeffe to Blanche Matthias, April 1929?, YCAL, quoted in ibid., 188.

86 O'Keeffe to Dorothy Brett, early April 1930, quoted in ibid., 200.

87 O'Keeffe to McBride, summer 1929, quoted in ibid., 190.

88 O'Keeffe to Pollitzer, c. Sept. 18, 1916, YCAL, quoted in Udall, *O'Keeffe and Texas*, 22.

89 Known to Dow was John Van Dyke's *The Desert: Further Studies in Natural Appearances* (New York, 1901), cited in Moffatt, *Dow*, 119.

90 Fenollosa, quoted in Willard Huntington Wright, *The Future of Painting* (London, 1923), 72.

91 Fenollosa, *Epochs*, 16. A copy of this two-volume set was in O'Keeffe's library in Abiquiu and exhibited at the Grolier Club in 1998. It is well-worn and repaired, suggesting frequent handling.

92 O'Keeffe, "About Myself," *O'Keeffe Exhibition of Oils and Pastels*, n.p.

93 Hegel's *Philosophy of Art* (English translation, 1920), quoted by Arthur Wesley Dow in "Art Teaching in the Nation's Services," in Addresses and Proceedings of the Fifty-fifth Annual Meeting of the National Education Association, Portland, Oregon, 1917, cited in Moffatt, *Dow*, 110.

94 Charles Eldredge, *Georgia O'Keeffe: American and Modern* (Fort Worth, 1993), 202.

95 Ansel Adams to Stieglitz, Sept. 21, 1937, cited ibid., 204.

96 Max Weber, "Fourth Dimension," *Camera Work* 25 (1910), quoted in Udall, "Beholding the Epiphanies," in *From the Faraway Nearby*, edited by Christopher Merrill and Ellen Bradbury (New York, 1992), 98.

97 Hartley, "Georgia O'Keeffe—A Second Outline in Portraiture," *On Art by Marsden Hartley*, edited by Gail R. Scott (New York, 1982), 105.

98 Laurence Binyon, *The Flight of the Dragon: An Essay on the Theory and Practice of Art in China and Japan, Based on Original Sources* (London, 1922), 58–59. O'Keeffe owned a copy of *The Flight of the Dragon*. See Fine, Glassman, and Hamilton, *Book Room*, 21. I thank Sarah Burt for bringing this reference to my attention.

99 Sarah L. Burt, *Georgia O'Keeffe Home and Studio National Historic Landmark Nomination*, U.S. Department of the Interior, National Park Service (Washington, D.C., 1998), 25.

100 Kuh, "Georgia O'Keeffe," 190.

101 Hartley to Stieglitz, Aug. 26, 1918, YCAL, quoted in Charles Eldredge, "The Faraway Nearby," in *Art in New Mexico, 1900–1945: Paths to Taos and Santa Fe* (New York, 1986), 154. The effect of

light in the patio seems repeated and even exaggerated by the beams of the roofless room, which she also used to showcase her white epoxy casting of a spiral.

102 Kuh, "Georgia O'Keeffe," 190.

103 Burt, *Landmark Nomination,* 26; Udall, *O'Keeffe and Texas,* 55.

104 Arthur Wesley Dow, "New Art Work in Progress or Planned," *Teacher's College Record* 16 (January 1915), 82 , quoted in Moffatt, *Dow,* 123.

105 O'Keeffe to Pollitzer, Feb. 4, 1916, quoted in Pollitzer, *Lovingly, Georgia,* 129.

106 Calvin Tomkins, "The Rose in the Eye Looked Pretty Fine," *New Yorker,* Mar. 4, 1974, 50.

107 As told in Christine Taylor Patten, *Miss O'Keeffe* (Albuquerque, 1992), 81–83, 155.

still life redefined

1 Norman Bryson, *Looking at the Overlooked* (Cambridge, 1990), 140.

2 Arthur W. Dow, *Composition: A Series of Exercises in Art Structure for the Use of Students and Teachers* (New York, 1913), 50.

3 For an analysis of Dow's contribution to modern art theory and practice see Joseph Masheck's introduction to the University of California Press's 1997 reissue of Dow's *Composition,* 1–61. The general study on Dow is Frederick C. Moffatt, *Arthur Wesley Dow, 1857–1922* (Washington, D.C., 1977).

4 See Herschel B. Chipp, *Theories of Modern Art* (Berkeley, 1968), 48–56, for an overview of symbolism.

5 See Sarah Whitaker Peters, *Becoming O'Keeffe: The Early Years* (New York, 1991), chapter 2, for a discussion of the aesthetic theories prevalent in the Stieglitz circle. I do not intend to recount all of this — I am more concerned with placing O'Keeffe's work visually in the context of Western still-life painting. Peter's text is the best source for information on the possible influences and development of O'Keeffe's early style. It is a thoroughly documented, analytical study — at least so far as this is possible with an artist as secretive as O'Keeffe.

6 After writing this I discovered that Barbara Novak had used precisely the same play on the French words to describe American flower painting in general and its special organic energy. See further her introduction to Ella M. Foshay, *Reflections of Nature* (New York, 1984), xv. Although I agree with Novak, my intention is to emphasize O'Keeffe's particular way of looking at and representing things — bones, shells, and leaves, as well as flowers.

7 Quoted in Keith L. Bryant, Jr., *William Merritt Chase: A Genteel Bohemian* (Columbia, Mo., 1991), 234.

8 Chase owned a number of Vollon paintings, including eight still lifes that were listed in a sale of 1912. William H. Gerdts, *Painters of the Humble Truth* (Columbia, Mo., 1981), 212.

9 Georgia O'Keeffe, *Georgia O'Keeffe* (New York, 1976), n.p. (introductory essay). Chase's class was obviously not for the beginner, because students were expected to work in oil and without the constant correction and advice that one gets in the first stages of art study. O'Keeffe had been through all of that in her early art training in Wisconsin and Virginia and during a year of classes at the School of the Art Institute of Chicago from 1905 to 1906 .

10 "A School on the Sands," *Brooklyn Daily Eagle,* Oct. 14, 1894, 9, quoted in Ronald G. Pisano, *A Leading Spirit in American Art: William Merritt Chase, 1849–1916* (Seattle, Wash., 1983), 89. See chapter 10 for information on Chase's teaching methods and philosophy.

11 It merits a color reproduction in Peters, *Becoming O'Keeffe,* 40, fig. 7.

12 As Charles Sterling noted, "Certain researches of Manet and Cézanne are inconceivable without Chardin. . . . Only in Cézanne and in post-Cézannian painting can we hope to find so much power in so much simplicity" (*Still Life Painting from Antiquity to the Twentieth Century,* rev. ed. [New York, 1981], 112–13). O'Keeffe certainly could have known about the Chardin from Chase, and she might well have conceived of her work as an homage to a master whom Chase admired, assuming that she chose the subject on her own. It is also possible that Chase himself set up the still life as a class assignment. We know that he owned many copper pots and pans, some of which undoubtedly found their way into arrangements for his Art Students League class. The dead rabbit could easily have been purchased in a New York city market. Although we do not know exactly how O'Keeffe arrived at her motif, what she does with it in comparison to the Chardin is interesting.

13 Quotation reprinted in O'Keeffe, *Georgia O'Keeffe,* n.p. (opp. pl. 23).

14 Katharine Kuh, "Georgia O'Keeffe," in Kuh, *The Artist's Voice: Talks with Seventeen Artists* (New York, 1962), 190–91.

15 O'Keeffe, *Georgia O'Keeffe,* n.p. (opp. pl. 100).

16 O'Keeffe to Blanche Matthias, n.d., Yale Collection of American Literature, Beinecke Rare Book and Manuscript Library, Yale University (hereafter YCAL). Letter

is on Shelton Hotel letterhead. O'Keeffe begins by saying it is snowing hard, and she ends the letter with "I wish I were a snowstorm."

17 O'Keeffe to William Einstein, c. July 1, 1937, YCAL.

18 Ibid.

19 Hamlin Garland, *A Son of the Middle Border* (New York, 1917), 133.

20 John Muir, *The Story of My Boyhood and Youth* (Madison, Wis., 1965), 53.

21 My mother, Marie Rink Pingel, was born in 1914 on a farm in Marathon County, Wisconsin, roughly 110 miles north of Sun Prairie. She attended a rural one-room, one-teacher grade school in the 1920s. When I talked with her about this experience (Dec. 2, 1997), she recalled that the school curriculum included a course on botany and one on agriculture, with textbooks. Several times during the schoolyear the teacher took all the students (grades 1–8) on a hike into the surrounding country to study flowers, trees, rocks, insects, and animals. They often walked a mile or more to the nearest creek or river. Students gathered specimens for identification and pressing, particularly flowers and leaves, throughout the seasons. Much of the emphasis during the walks was on observation of nature. The agricultural course instructed pupils about livestock: types of cows, horses, pigs, chickens, and ducks, and their life cycles and care.

22 Lambeth, a medical doctor at the University of Virginia in Charlottesville, was also a professor of field botany who taught a summer school course on identifying southern trees. He had written the book as a text for the course, and one wonders if O'Keeffe might have enrolled in the class while in Charlottesville. The book remained in her possession until the end of her life. It is signed on the front endpaper: "Georgia O'Keeffe / University — Virginia /August 5th — 1913 — ." It was included in the Grolier Club's 1997–98 exhibition, *The Book Room: Georgia O'Keeffe's Library in Abiquiu.*

23 William Alexander Lambeth, *Trees and How to Know Them: A Manual with Analytical and Dichotomous Keys of the Principal Forest Trees of the South* (Atlanta, Ga., 1911), 34.

24 Roxana Robinson, *Georgia O'Keeffe* (New York, 1989), 28.

25 Aldo Leopold, *A Sand County Almanac* (New York, 1949; reprint ed., 1968), 26. Leopold was born in Iowa in the same year as O'Keeffe, 1887; he died in 1948. He joined the U.S. Forest Service in 1909 and by 1924 was the associate director of

the Forest Products Laboratory in Madison. The University of Wisconsin created a chair of game management for him in 1933. A great naturalist and conservationist, Leopold writes with an aesthetically honed perception about the passing of the natural year on his Sand County, Wisconsin, farm north of Sun Prairie. His account of cutting down a great bur oak that had been hit by lightning is a classic of nature writing, an unforgettable description that ties the saw bites through the tree's growth rings to Wisconsin's natural history events.

26 Anita Pollitzer, *Lovingly, Georgia: The Complete Correspondence of Georgia O'Keeffe and Anita Pollitzer,* edited by Clive Giboire, introduction by Benita Eisler (New York, 1990), 289–90.

27 See Sarah Greenough, "From the American Earth: Alfred Stieglitz's Photographs of Apples," *Art Journal* 41 (Spring 1981), 46–54.

28 "I Can't Sing, So I Paint! Says Ultra Realistic Artist; Art Is Not Photography—It Is Expression of Inner Life!: Miss O'Keeffe Explains Subjective Aspect of Her Work," *New York Sun,* Dec. 5, 1922, quoted in Laurie Lisle, *Portrait of an Artist: A Biography of Georgia O'Keeffe* (Albuquerque, 1986), 278.

29 Calvin Tomkins, "The Rose in the Eye Looked Pretty Fine," *New Yorker,* Mar. 4, 1974, 42.

30 Sarah W. Peters in *Becoming O'Keeffe,* 262, discusses the early leaf canvases and suggests that O'Keeffe used a Dow exercise to inspire some of these patterns.

31 Pierre Schneider, *Matisse* (New York, 1984), 12.

32 Robinson, *O'Keeffe,* 456.

33 For a recent account of Dada portraiture see Beth Venn, "New York Dada Portraiture: Rendering Modern Identity," in Francis M. Naumann, *Making Mischief: Dada Invades New York* (New York, 1996), 272–79.

34 Lewis Mumford to O'Keeffe, Feb. 4, 1929, YCAL.

35 Pollitzer, *Lovingly, Georgia,* 46.

36 Quoted in Helen Vendler, ed., *Voices and Visions: The Poet in America* (New York, 1987), 175.

37 William Carlos Williams, *Kora in Hell: Improvisations* 27, no. 2 (1920), reprinted in *The William Carlos Williams Reader,* edited by M. L. Rosenthal (New York, 1966), 109.

38 From his Wisconsin childhood John Muir remembered: "Oftentimes the heavens were made still more glorious by auroras, the long lance rays, called 'Merry Dancers' in Scotland, streaming with startling

tremulous motion to the zenith. Usually the electric auroral light is white or pale yellow" (Muir, *Story of My Boyhood,* 163–64).

39 See Peters, *Becoming O'Keeffe,* for a complete discussion of photographic influences on O'Keeffe's style.

40 Maria Oakey Dewing, "Flower Painters," *Art and Progress* 6, no. 8 (June 1915), 255.

41 See Jennifer Martin, "Portraits of Flowers: The Out-of-Door Still-Life Paintings of Maria Oakey Dewing," *American Art Review* 4 (December 1977), 48–55, 114–18.

42 Dewing describes the screen in "Flower Painters and What the Flower Offers to Art," 1915.

43 Bernard Dunstan makes this observation about painters and the use of color in *Starting to Paint Still Life* (New York, 1969), 100.

44 Charles Demuth to O'Keeffe, Mar. 7, 1926, YCAL.

45 Ibid.

46 Reviewing the exhibition of 1928, McBride wrote: "These and similar paintings, content those who respond to the painters touch and to her clarity of color and mean just what the spectator is able to get from them and nothing more. To overload them with Freudian implications is not particularly necessary." See Barbara Buhler Lynes, *O'Keeffe, Stieglitz, and the Critics, 1916–1929* (Ann Arbor, Mich., 1989), 275.

47 See Peters, *Becoming O'Keeffe,* 259.

48 John Berger, *Ways of Seeing* (London, 1972), 7.

49 Norman Bryson, *Vision and Painting: The Logic of the Gaze* (London, 1983), xiv, quoted in Chris Jenks, ed., *Visual Culture* (New York, 1995), 13.

50 Writing to Rebecca Salsbury James in 1941, O'Keeffe says, "Thanks also for the Jimson weed. I am watching and watering the wilted heads hopefully—." In a follow-up letter she reports, "One of your plants is about to have a flower—a great event in my barren patio—there are several buds but there have been buds before that fell off—this one is really coming out" (O'Keeffe to James, probably 1941, YCAL).

51 Edgar P. Richardson et al., *Charles Willson Peale and His World* (New York, 1983), 38.

52 Ibid.

53 O'Keeffe, *Georgia O'Keeffe,* n.p. (opp. pl. 84). The jimson weed, *Datura stramonium,* is actually an alteration on Jamestown weed, a name that referred to the location where it was first collected and classified.

54 Pollitzer, *Lovingly, Georgia,* 324. O'Keeffe rejected Anita Pollitzer's manuscript about

their early relationship, forbidding her to publish *A Woman on Paper: Georgia O'Keeffe.* She later sent Pollitzer some thirty-one pages of notes, including many that disagreed with Pollitzer's description of her as happy, content, or pleased.

55 O'Keeffe to James, Aug. 9, 1931, YCAL.

56 Quoted in *Georgia O'Keeffe: Selected Paintings and Works on Paper* (Dallas, 1986), 21.

57 Garland, *Son of the Middle Border,* 85.

58 The image was taken at the end of Hayden's survey, which followed the old Oregon-California trail west and returned along the Union Pacific railroad line. Peter B. Hales, *William Henry Jackson and the Transformation of the American Landscape* (Philadelphia, 1988), 93.

59 See Richard White, "Animals and Enterprise," in *Oxford History of the American West* (New York, 1994), 236–73, for a general account of the role wild and domestic animals played in the history of the West.

60 The Farney painting is reproduced in Charles C. Eldredge et al., *Art in New Mexico, 1900–1945: Paths to Taos and Santa Fe* (New York, 1986), 36.

61 Although I have not had the opportunity to hear her, Wanda Corn has lectured on O'Keeffe's bone paintings in relation to earlier depictions of animal bones in the western landscape and intends to publish this material. My research has been done over the past decade for American studies lectures on the West.

62 Pronghorn, for example, could move through conventional barbed-wire fences but died cornered in blizzards that drove them against close-woven sheep fences. White, "Animals and Enterprise," 270.

63 Leopold, *Sand County Almanac,* 127.

64 White, "Animals and Enterprise," 269.

65 Influenced by the still-life traditions of northern Europe, Harnett actually painted four versions of *After the Hunt,* the first three in Munich, where he was studying (two in 1883 and one in 1884) and the fourth in Paris in 1885. This is the one he exhibited at the Paris Salon and then brought to New York in 1886, where he sold it to Theodore Stewart, a saloon keeper in Warren Street. Specially framed and lit, the painting gained immediate notoriety and fame. See Elizabeth Jane Connell, "After the Hunt," in Doreen Bolger et al., *William M. Harnett* (New York, 1992), 277–87.

66 Cleve Gray, ed., *John Marin by John Marin* (New York, 1977), 54, from an undated manuscript.

67 O'Keeffe, *Georgia O'Keeffe,* n.p. (opp. pl.

68 Quoted in D. Scott Atkinson and Nicolai Cikovsky, Jr., *William Merritt Chase: Sum-*

illustration credits

Unless otherwise noted, photographs were supplied by the owners of the works of art listed in the captions. All rights reserved.

Thanks to the following individuals for assistance with rights and reproductions for the supplementary illustrations in the catalogue: Denise J. H. Johnson, Registrar, Addison Gallery of American Art, Phillips Academy, Andover; Courtney DeAngelis, Assistant Registrar, Amon Carter Museum, Fort Worth; Merriam Sunders, Ansel Adams Publishing Rights Trust, Carmel, California; Ellen Cordes, Head of Public Services, and Alfred Mueller, The Beinecke Rare Book and Manuscript Library, Yale University, New Haven; Cristina Segovia, Rights and Reproductions, Corcoran Museum of Art, Washington, D.C.; Evans Gallery, Portland, Maine; Mary Haas, Rights and Reproductions, Fine Arts Museum of San Francisco; Karen Casey Hines, Assistant Registrar, The Frances Lehman Loeb Art Center, Poughkeepsie, New York; Scott A. Thompson, Rights and Reproductions, Freer Gallery of Art, Washington, D.C.; Janice Madhu, George Eastman House, Rochester, New York; Maria Umali, Gilman Paper Company, New York; Amy Densford, Photography Coordinator, Hirshhorn Museum and Sculpture Garden; Catherine Phlanger, Musée du Louvre, Paris; Sue Davidson Lowe; Mikki Carpenter, Director, Department of Photographic Services and Permissions, The Museum of Modern Art, New York; Robert E. Richardson, Division Director, Special Media Archives Services Division, National Archives at College Park, Maryland; Daniel H. Holeva, Curator of Collections and Exhibitions, Museum of the Southwest, Midland, Texas; Stefan Stahle, The National Swedish Art Museums, Stockholm; Wayne Furman, The New York Public Library; Grace Darby, *The New Yorker,* New York; Betty Bustos, Panhandle-Plains Historical Museum, Canyon, Texas; Ree Mobley, Photo Archivist, Pikes Peak Library District, Colorado Springs; Mary Morel, Time Life Syndication, New York; Michael Plunkett, Director of Special Collections, and Margaret Hrabe, University of Virginia Library, Charlottesville; Joe McGregor, U.S. Geological Survey Photographic Library, Denver; Tony Vaccaro, Photography, Long Island City; Woody Camp, Woodfin Camp and Associates, New York; Ricardo Sardenberg, Associate Director, Zabriskie Gallery, New York

PLATES

2, 3, 4: Photograph by Lee Ewing. *2, 3, 4, 42, 43, 61:* © 1998 Board of Trustees, National Gallery of Art, Washington, D.C. *6:* © 1989 The Georgia O'Keeffe Foundation. *6, 24, 36:* Photograph by Malcolm Varon, N.Y.C. © 1998. *7:* Photograph by George Hixson, Houston. *12, 20, 39:* © The Georgia O'Keeffe Foundation, 1991; Photograph courtesy of The Gerald Peters Gallery, Santa Fe, New Mexico. *13, 32:* Photograph by Greg Heins. *15:* Photograph © 1987 The Metropolitan Museum of Art. *15, 57:* Photograph by Malcolm Varon, N.Y.C. *16:* Photograph by Edward Owen. *17:* Photograph by Peter Harholdt. *26, 28, 58:* Photograph © 1998 Museum of Fine Arts, Boston, All Rights Reserved. *30:* Photograph © 1998 The Art Institute of Chicago, All Rights Reserved. *31, 53:* © The Cleveland Museum of Art. *38:* Photograph by Glenn Castellano. *43:* Photograph by Bob Grove. *44:* Photograph by Bill Finney. *45:* Photograph by Damian Andrus. *47:* Photograph by Malcolm Varon, N.Y.C. © 1997. *50:* Photograph © 1984 The Metropolitan Museum of Art.

FIGURES

p. i, 7, 16, 40, 73: © The Metropolitan Museum of Art, All Rights Reserved. *p. ii, 78:* © 1979 Amon Carter Museum, Fort Worth, Texas, Bequest of Laura Gilpin. *6:* © Photograph by Lee Ewing. *6, 9, 11, 13, 44, 64:* © 1998 Board of Trustees, National Gallery of Art, Washington, D.C. *12:* Photograph © 1987 The Metropolitan Museum of Art. *12, 87:* Photograph by Malcolm Varon, N.Y.C. © 1998. *15:* © 1996 Man Ray Trust, ARS-USA; Photograph by Lee Stalsworth. *20:* © 1929 The New Yorker Magazine, Inc., All Rights Reserved. *21, 22:* Photograph by Richard Carafelli. *21, 22, 82:* © 1998 Board of Trustees, National Gallery of Art, Washington, D.C. *23, 80:* © Pikes Peak Library District. *24, 25, 81:* © Todd Webb, Courtesy of Evans Gallery, Portland, Maine. *27:* Photograph © 1990 Indianapolis